BETTER PICTURE GUIDE TO

Vacation & Holiday Photography

LAIRD LIBRARY
Glasgow College of Building & Printing
60 North Hanover Street
Glasgow G1 2BP

0141 566 4132

MICHAEL BUSSELLE

3230012863

BETTER PICTURE GUIDE TO

Vacation & Holiday Photography

A RotoVision Book Publishėd and Distributed by RotoVision SA Rue Du Bugnon 7 1299 Crans-Près-Céligny Switzerland

RotoVision SA, Sales & Production Office Sheridan House, 112/116A Western Road Hove, East Sussex, BN3 1DD, UK

Tel: +44 (0) 1273 72 72 68 Fax: +44 (0) 1273 72 72 69

Distributed to the trade in the United States by: Watson-Guptill Publications 1515 Broadway New York, NY 10036 USA

Copyright © RotoVision SA 2000

All rights reserved. No part of this publication may be reproduced, stored in a retrieval system or transmitted in any form or by any means, electronic, mechanical, photocopying, recording or otherwise, without permission of the copyright holder.

The photographs used in this book are copyrighted or otherwise protected by legislation and cannot be reproduced without the permission of the holder of the rights.

ISBN 2-88046-443-9

Book design by Angie Patchell Illustrations by Katherine Williamson

Production and separations in Singapore by ProVision Pte. Ltd.

Tel: +65 334 7720 Fax: +65 334 7721

Contents

Destinations		6	In the Frame	70
	The Seaside	88	Choosing a Viewpoint	72
	Lakes & Mountains	14	Composing the Image	78
	Towns & Cities	20	Magic of Light	84
	Countryside & Villages	26	Creating Impact	90
	Trains, Boats & Planes	32	Using Colour Creatively	96
	Festivals & Events	36		111111
			Cameras & Equipment	100
Excursions		38		
			Choosing a Camera	102
	A Holiday Diary	40	Camera Types	104
	Capturing Local Colour	46	Choosing Lenses	106
	Photographing Views	52	Camera Accessories	108
	Photographing the Sights	58	Apertures & Shutter Speeds	110
	Photographing People	64	Understanding Exposure	112
	Control of the Contro	ender in the second	Choosing Film	116
			Using Filters	118
		than the state of	Travelling with a Camera	120
	erite History (Mary September 1985)		Finishing & Presentation	122
			Glossary	126

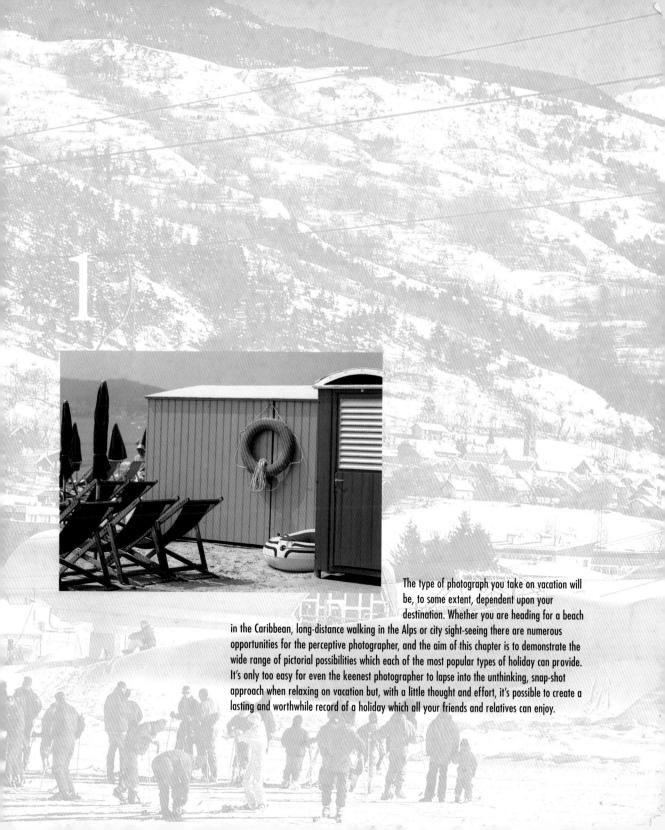

The Seaside

Probably the most popular of all holiday destinations, the seaside offers the greatest variety of opportunities for interesting and colourful photography, ranging from beach activities and seascapes to harbours and fishing boats, together with all the photogenic trappings of the seaside, such as rock pools, beach huts, deck chairs and lighthouses. It is also one of the easiest situations in which to produce muddled and unsatisfying pictures unless you are very selective and compose your pictures with care.

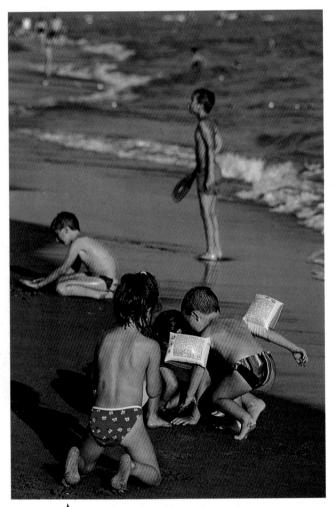

ATechnical Details

35mm SLR Camera with a 70-210mm zoom lens and Kodak
Ektachrome 100 SW.

Seeing

I'd been watching this **Group** of children playing on a beach in Spain's Costa del Sol for a while thinking that there was the possibility of a picture. But the beach was very busy and there were too many people around the children and also **behind them** in the sea.

Thinking

I felt sure that if I Waited long enough the area would clear a little and if I found the right Viewpoint I might be able to separate the group I was interested in from their Surroundings.

Acting

I suddenly saw my Opportunity from a spot where the background was much less cluttered and the children were placed in quite a pleasing arrangement. I used a long-focus lens to crop the image quite tightly and to exclude as many unwanted details as possible.

Rule of Thumb

You need to take extra care of your equipment when shooting on a beach as both salt water spray and sand can cause considerable damage to cameras and lenses. It is wise to keep each item in a sealed plastic bag inside your camera case until needed.

Technical Details

▼35mm SLR Camera with a 75—300mm zoom lens, an 81A warm-up filter and Fuji Velvia.

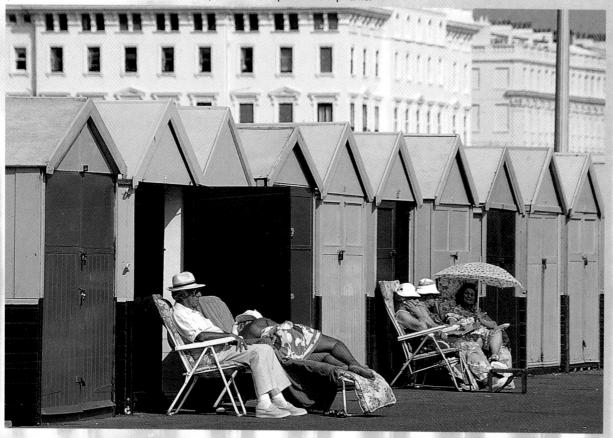

This photograph was taken on the promenade at Hove in Sussex, UK. I was attracted by the juxtaposition of the rather garish beach huts and background of quite elegant facades. I chose a viewpoint which allowed me to include the group of holiday makers and one which was distant enough to make the background houses rise above the roofs of the huts. I needed to use a long-focus lens to enlarge the most interesting area of the scene.

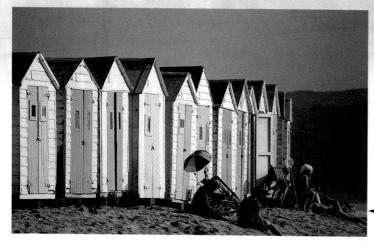

These beach huts were at Woolacombe in North Devon, UK, and I chose a quite distant viewpoint at a fairly acute angle to the row of huts and used a long-focus lens in order to create the impression of compressed perspective.

Technical Details

35mm SLR Camera with a 75—300mm zoom lens, an 81A warm-up filter and Fuji Velvia.

The Seaside

Seeing

These catamaran fishing boats were pulled up onto the beach at Negombo in Sri Lanka. I was initially attracted by the Contrast between their rust-brown sails and the deep blue sky and started to look for a suitable VIEWPOINT

Thinking
As I studied the scene more carefully I realised that the distant palm trees and the redroofed hut could be used to add interest to the image and would also show more of the location and its atmosphere.

Acting

From this spot, I found I could create enough Separation between the two sails and at the same time place the palm trees and red roof just to one side of them. I framed the shot to include all of the boats but tightly enough on the right-hand side to **exclude** a parked truck which rather spoilt the mood of the picture

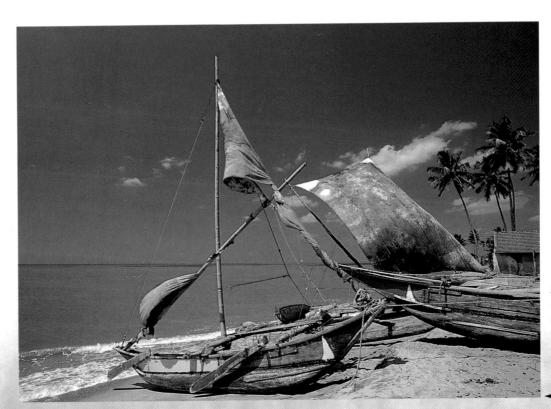

Yrechnical Details35mm SLR Camera with a 28—70mm zoom lens, 81B warm-up and polarising filters, and Fuji Velvia.

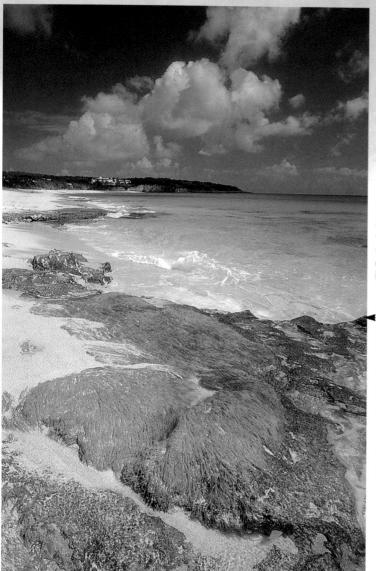

Even the most stunning beach will not produce a good picture unless you take measures to create a pleasing composition. Often the most effective way is to find an interesting foreground, like these colourful rocks on a Caribbean beach. This will introduce a much needed element of contrast to the sand and sky and help to give the image a sense of depth and distance. This shows how using the upright format has allowed a much larger area of foreground to be included adding both depth and impact to the image.

Technical Details

35mm SLR Camera with a 20—35mm zoom lens, 81B warm-up and polarising filters, and Fuji Velvia.

Rule of Thumb

When you see a potential picture, it's better to explore the possibilities that different viewpoints will give you rather than shooting immediately from the spot where you first saw the scene.

Looking more closely at a scene is often an effective way of producing pictures with a difference and adding variety to photographs taken at the seaside. These limpets were on a rock in North Devon, UK, and I used a macro lens to allow me to focus closely enough to fill the frame with a small area to reveal the rich texture and detail of the shell

Technical Details

35mm SLR Camera with a 90mm macro lens, an 81A warm-up filter and Fuji Velvia."

The Seaside

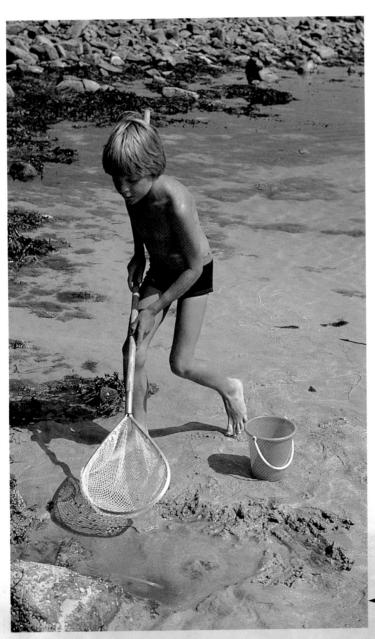

Rule of Thumb

When photographing people in this way, having an interesting but unobtrusive background is usually a major factor in the success of the picture. It's best to move around your subject looking for a viewpoint where this can be combined with a pleasing angle on your subject.

Many people will set up holiday pictures of their friends and family, making them stop what they are doing and look at the camera, but it is often far more pleasing to take pictures with as little disturbance of the subject as possible, and having someone looking self-consciously into the camera will usually detract from the mood of the occasion. With this picture I simply tracked my young subject for a while as he was engrossed in his fishing until he moved into a spot where there was an effective background and he adopted a nice pose.

Technical Details

35mm SLR Camera with a 35—70mm zoom lens, an 81A warm-up filter and Kodak Kodachrome 64.

Seeing
I saw this Colourful assemblage of seaside equipment on a beach in the Italian Riviera and was immediately struck by the pleasing mix of bright, bold colours

Thinking

I realised that, unless I was very careful, the outcome could easily be a muddle with each colour vying for attention, and the resulting image suffering from an unbalanced composition

Acting

I decided that the best approach was to be Very selective and not to try and get too much into the subject. I found this viewpoint where, even by Cropping the image quite tightly with a long-focus lens, I was able to include enough of each of the key details of the scene to create a balanced composition without losing the essence of the place.

Technical Details

▼Medium-format SLR Camera with a 150mm lens, an 81A warm-up filter and Kodak Ektachrome 64.

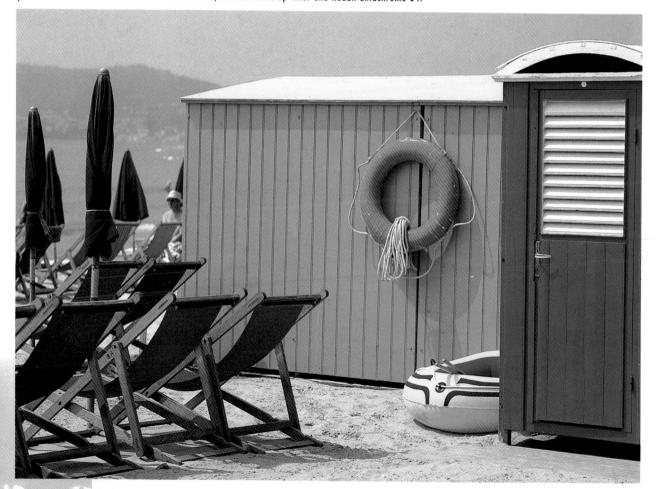

Lakes & Mountains

Like the seaside, lakes and mountains can be all things to all people as well as a holiday destination. Whether it is the relaxing atmosphere and beautiful scenery of a summer vacation in the high alps, the energy and excitement of a winter sports holiday, adventure sports or the pleasures of sailing, fishing or boating, the photographic potential is vast, ranging from dramatic landscapes to action photography and nature subjects.

Seeing

It was a crisp, clear day in the French Alps when I passed through this ski resort. There had been a recent fall of snow so the slopes looked quite fresh and White, the sky was a deep, clear blue and the sunlight had a good sharp edge.

Thinking

These are conditions in which more distant views can be successful and I wanted to produce a picture which showed something of both the setting and the activity. The group of skiers waiting for the chair lift seemed to be the obvious choice for a focus of attention and would also provide a much needed element of colour in the image.

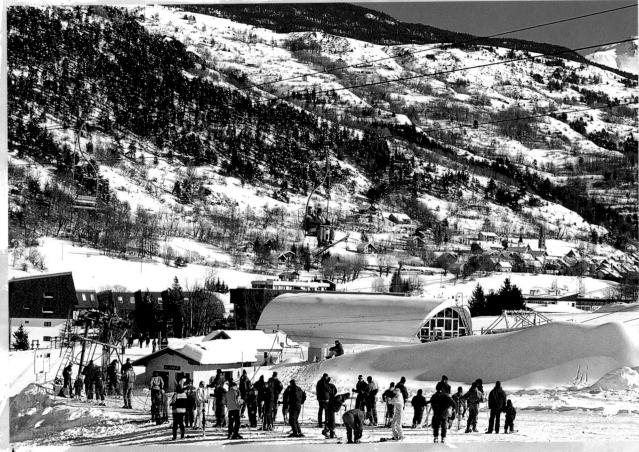

Technical Details

35mm SLR Camera with a 24—85mm zoom lens, 81B warm-up and polarising filters, and Kodak Ektachrome 100 SW.

Acting

I decided to look for a Viewpoint which would allow me to look down towards the skiers, so I walked a little way up the slope away from them. I framed the shot, using a wide-angle lens, in a way which placed the skiers at the bottom of the frame with the sky just visible above the distant mountain top.

Technical Details

35mm SLR Camera with a 70—200mm zoom lens, an ▼81A warm-up filter and Kodak Ektachrome 100 SW.

35mm SLR Camera with a 24—85mm zoom lens, 81B warm-up and polarising filters, and Kodak Ektachrome 100 SW.

Even without an autofocus camera, photographing action of this type is not so difficult. The secret is to find a good viewpoint which provides a good view of the action, and also places an uncluttered area of the scene in the background, and then determine where your subject should be to create the best composition. You need only then to follow your chosen subject in the viewfinder, panning the camera smoothly to keep pace, and make your exposure, using the fastest practical shutter speed, when he or she arrives in the chosen spot.

I chose a viewpoint for this picture which enabled me to use the line of skiers as foreground interest and framed the shot so that they were on the left-hand side of the frame with the ski lift support more or less in the centre. I waited until a chair arrived at this spot before shooting.

Technical Details... 35mm SLR Camera with a 75—300mm zoom lens, 818 warm-up and polarising filters, and Kodak Ektachrome 64.

Lakes & Mountains

Seeing

saw this scene on the same lake side as the picture on the opposite page. In this case I was attracted to the powerful contrast between the rich, reddish-coloured wood and the blue water, as well as the pattern which the upright poles of the landing stage had created.

Thinking

I felt that the image would have more impact if I framed the image very tightly and excluded all but the most important details. Limiting the image to just two colours would also place more emphasis on the pattern element of the image.

Acting

I chose a viewpoint which created the best separation between the upright poles and framed it using a long-focus lens, so the sky was excluded, and there was just a small amount of the water below the base of the boats; the pole on the right-hand side of the picture was just included. I used a polarising filter to increase the image's colour saturation.

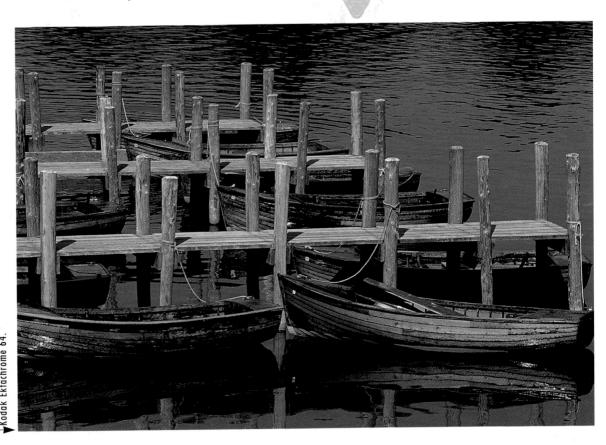

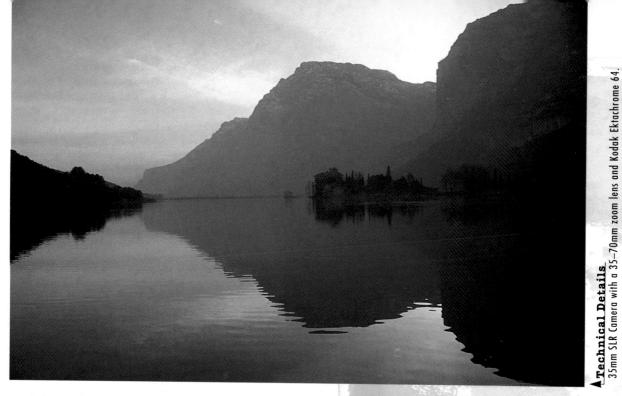

I took this photograph of Lake Garda in Italy late one winter's afternoon. I was attracted by the fact that the very still water had created an almost mirror-like reflection of the mountains, choosing a viewpoint and framing the shot to emphasise this aspect of the scene. The near-dusk light had created a bluish quality which I thought added to the picture's atmosphere; I did not use a warm-up filter in order to accentuate this.

I used a wide-angle lens for this shot taken in England's Lake District because I wanted to create a strong impression of depth and distance in the picture. This has been emphasised by choosing a viewpoint which placed me close to the boats and framing the image to also include distant details. I used a small aperture to ensure the image was sharp from the nearest to the furthest details.

Technical Details

35mm SLR Camera with a 20mm wide-angle lens, 81B warm-up and polarising filters, and Kodak Ektachrome 64.

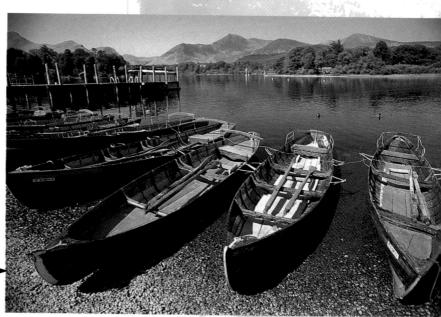

Lakes & Mountains

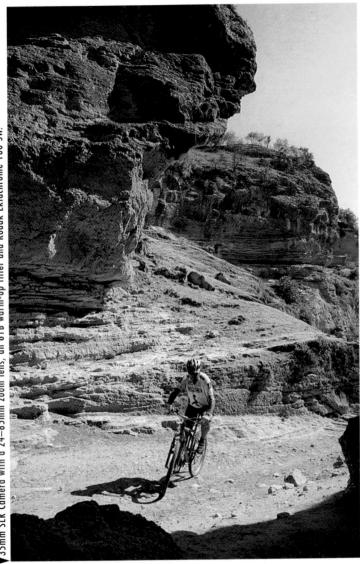

My friend Stuart is a keen mountain biker and frequently goes up into the mountains near Alhama de Granada in Spain's Andalucia region for a day's biking, often in temperatures of over 40°C. On this occasion I accompanied him by car, with a view to shooting some pictures of him in action in the gorges near Alhama. I chose a viewpoint which placed a dramatic area of the cliff behind him and framed the image so that he was at the base of the picture with the rocks towering above.

Seeing

I saw this scene while driving through the Flinders ranges in South Australia's outback. I was attracted by the huge old gum tree and the way its leaning trunk and jutting branch acted as a frame to the distant mountains.

Thinking
I shot a few frames of

shot a few frames of the scene before realising that it would make a nice setting for a shot of the car and this would also add an element of interest and scale to the picture.

Acting

I chose a viewpoint which allowed me to place the tree trunk to the left of the most prominent peak and the road on the extreme right of the picture. I then asked my friend to drive the car into this spot and, using a wide-angle lens, framed the shot so that the jutting branch was just included at the top of the frame and the adjacent gum tree on the left was also within the picture area.

35mm SLR Camera with a 24—85mm zoom lens, an 818 warm-up filter and Kodak Ektachrome 100 SW Technical Details

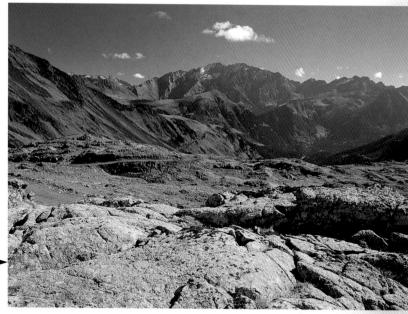

A very clear day with a strong blue sky and a crystalline atmosphere provided the ideal conditions to shoot this view of the Spanish Pyrenees near the town of Bielsa, where a number of rough tracks lead up high into the mountains. I used a wide-anale lens which allowed me to include some rocks in the close foreground, enhancing the impression of depth and distance. I used a polarising filter to further enhance the image's colour saturation and clarity, and a warm-up filter to counteract the bluish quality which can be created when shooting at high altitudes.

Technical Details

Medium-format SLR Camera with a 55mm wide-angle lens, 81C warm-up and polarising filters, and Fuji Velvia.

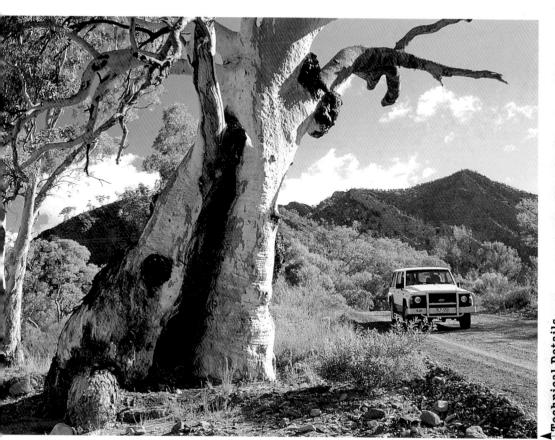

'Technical Details. 35mm SLR Camera with a 24—85mm zoom lens, 81B warm-up and polarising filters, and Fuji Velvia.

Towns & Cities

City breaks have become a very popular form of vacation and have the advantage that they can be enjoyed at any time of the year. They are also much less weather dependent than many

other types of holiday and this is reflected in the photographic possibilities, as the colourful and lively nature of city life can provide plenty of opportunities when the weather is dull, as well as creating the opportunity for taking interesting photographs after dark.

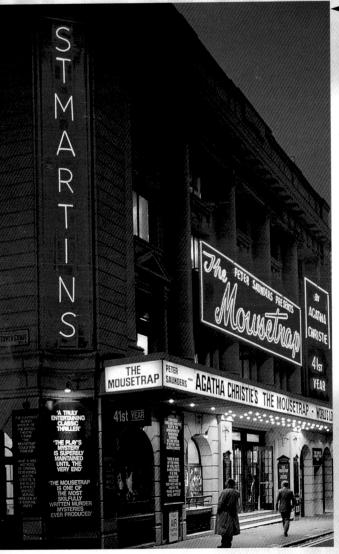

Technical Details

35mm SLR Camera with a 75—300mm zoom lens and Fuii Provia.

This photograph was taken in London's theatre land not long after the sun had gone down. I used a long-focus lens to frame the image tightly, restricting the image to the most strongly lit part of the scene and excluding any especially dark areas which lacked detail.

I took this photograph in the lively old streets of Brussels on a summer evening. The street was very well lit and some weak daylight remained, but, although the scene was predominately lit by artificial light, I opted to use daylight-type transparency film because I thought the resulting orange colour-cast would contribute to the image's atmosphere.

Technical Details

▼35mm SLR Camera with a 24—85mm zoom lens and Fuji Provia.

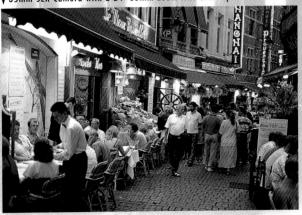

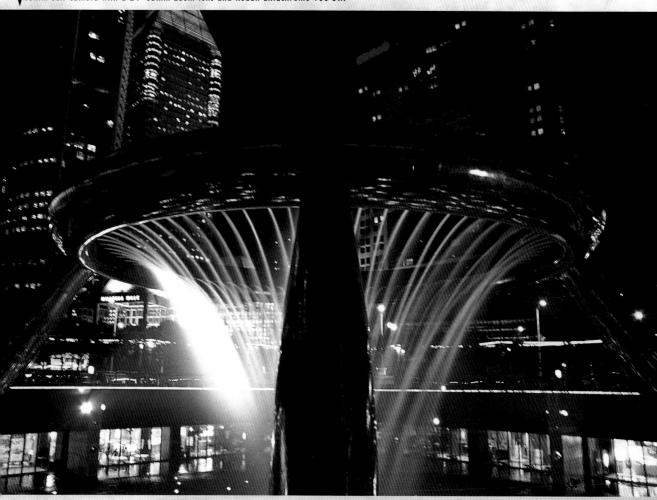

Seeing

This is Singapore's Fountain of Wealth, reputed to be the largest of its kind in the world. At certain hours, the computer-controlled fountain is turned into a sort of aquatic fireworks display in which the ever Changing patterns created by the jets of water are lit by multi-coloured lasers.

Thinking

During my visit the first display of the evening was long after sunset and the sky was completely dark. The only way to overcome this was to look for a VIEWPOINT from which I could place the most strongly illuminated area of the background immediately behind the fountain.

Acting

then framed the image in a way that excluded all the darker areas of the scene, waiting before shooting until the laser display lit the water most evenly. My difficulty was compounded by the fact that I did not have my tripod with me and the exposure needed was in the order of two seconds. I managed to find a lamppost close to my chosen viewpoint and was able to brace the camera firmly enough against it to avoid camera shake.

Towns & Cities

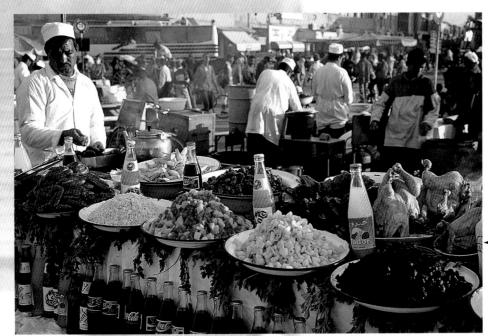

Street life is a feature of the urban environment which can be particularly rewarding for photographers and will help to create a sense of place in a record of a city. This picture was taken in the main square of Marrakech, Morocco, where in the evenings, dozens of small food stalls are set up with a mouth-watering variety of delicacies to sample. I used a long-focus lens to isolate a small section of the scene and used a wide aperture so the background details were slightly soft and not too intrusive.

Technical Details

35mm SLR Camera with a 20-35mm zoom lens, an 81A warm-up filter and Fuji Velvia.

Technical Details

35mm SLR Camera with a 28mm shift lens, an 81A warm-up filter and Fuji Provia.

This photograph is of the Lion's Court in the Alhambra Palace in Granada, Spain. I used a wideangle lens and tilted the camera upwards to create a deliberate distortion. I took care to avoid showing the base of the building as this tends to make tilted camera pictures look awkward.

Technical Details

35mm SLR Camera with a 24—85mm zoom lens, an 81A warm-up filter and
Kodak Ektachrome 100 SW.

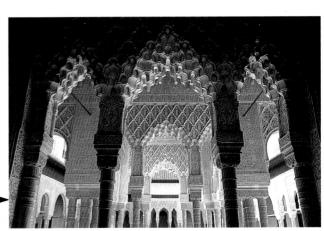

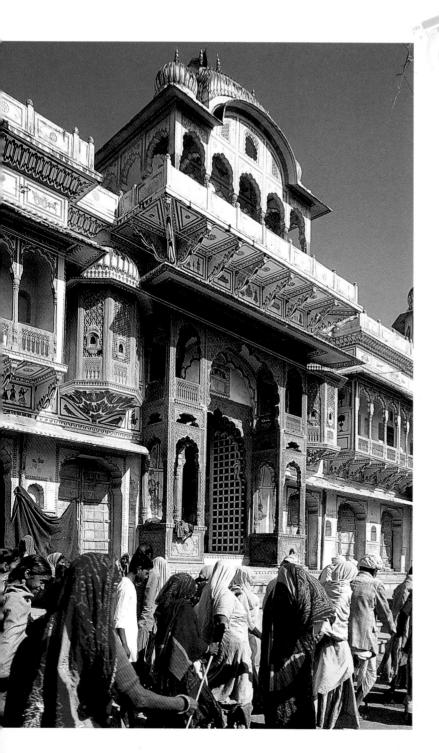

Seeing

Rajasthan must be one of the most COlourful places on earth, I took this picture in the town of Pushkar, famous for its camel fair and for its NUMEROUS TEMPLES. I was struck by the way this particular temple was lit; from this angle the sunlight had created a very pleasing quality in the STONEWORK with rich textures and bold colours.

Thinking

I wanted to show as much of the building's facade as possible but it was a narrow street and very busy so the Choice of viewpoint was limited

Acting

I found that from this position, using a Wide-angle lens, I could include most of the temple's facade. This meant including some of the People in the foreground but I felt their colourful saris would add impact to the picture and also enhance the atmosphere of the place.

Rule of Thumb

When photographing buildings in city streets it's sometimes tempting to tilt the camera upwards to include the top. This should be done with care as it will result in the vertical lines of the building converging and giving the appearance of it toppling over. If you do tilt the camera, make sure it is done in a positive and deliberate way.

Towns & Cities

Seeing

The charming old town of Bruges in Belgium was the location for this picture of the Small Square of Walplein. I wanted to capture something of the leisurely atmosphere of the place with its horse-drawn carriages and pavement cafes.

Thinking

I walked around the square looking for a VIEWPOINT which would allow me to include both the cafe tables and the row of old houses, which were lit very nicely by the early morning sunlight.

Acting

This spot seemed to achieve both aims. Although the cafe was mainly in shadow, this one table at the edge was well lit and I framed the image to include only this along with the buildings' facades in the background. I then waited until a carriage arrived in the street before shooting.

Technical Details ▼35mm SLR Camera with a 35—70mm zoom lens, an 81A warm-up filter and Fuji Provia.

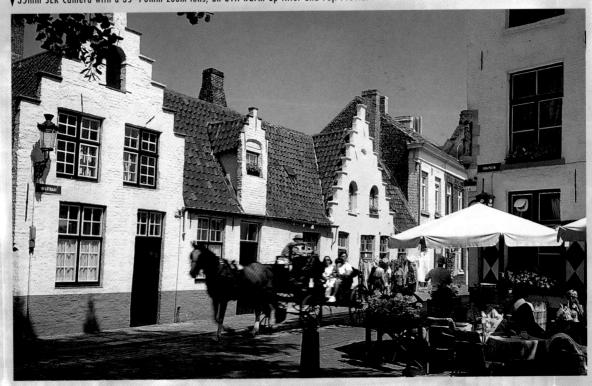

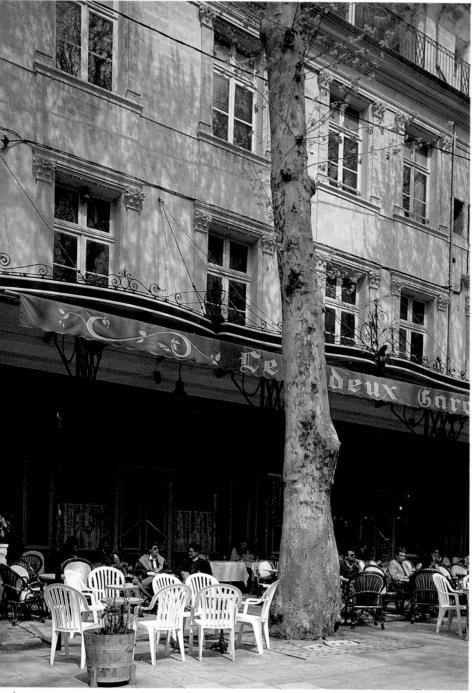

ATechnical Details

Medium-format SLR Camera with a 105-210mm zoom lens, an 81A warm-up filter and Fuji Velvia.

Aix-en-Provence is one of the most atmospheric cities in France known for its shady, tree-lined avenues and pavement cafes. This scene appealed to me because of the colour of the cafe's facade (one of Aix's hest loved) and the dappled sunlight which was filtering through the trees. It was springtime so the foliage was not very dense and the sunlight was softened by the atmospheric haze, otherwise the effect might well have been too contrasty. I used a long-focus lens to isolate a small area of the scene from my viewpoint on the other side of the avenue, and framed the shot in a way that placed the plane tree about one third of the way across the image.

Rule of Thumb

Taking photographs in busy cities is often made difficult because of the crowds of tourists who invariably throng the pavements and places of interest. It's well worth getting up a little early to avoid this as far fewer people will be around before breakfast and there is the added bonus of the low-angled sunlight providing a more pleasing and atmospheric light at an early hour.

Countryside & Villages

One of my greatest pleasures is driving through unspoilt countryside with a good map and the time to explore. The most enjoyable experiences and most memorable times are frequently those which result from a chance discovery of a charming village or quiet scenic route which are not in the guide books, and these are often the occasions when you take the photographs you are most pleased with.

I saw this scene in the small New England village of Wilmington, USA. It seemed to contain all the ingredients which characterise these villages: white clapper-board houses, wooden decks, country crafts and an American flag. I framed the shot tightly to emphasise these elements and included enough of the green tree and blue sky to create a contrast.

Seeing

In fact, this village green is quite close to my home and I was driving past early one summer's morning when I saw this game in progress. The way the distant church and the fresh, green foliage were lit by the sunlight, still quite low in the sky, were the factors which appealed to me about the scene.

Thinking

I set about looking for a VIEWPOINT which would incorporate these elements most effectively. From this spot I could include the overhanging branch from the nearest tree and it also gave me a good three-quarter VIEW of the wicket and separated the players quite well.

Acting I framed the shot so that the overhanging branch filled the top right quarter of the frame and there was a comfortable amount of space on the other side of the church. I then waited until there was a moment of action

before making my exposure.

Technical Details

35mm Viewfinder Camera with a 45mm lens, an 81B warm-up filter and Fuji Provia.

I found this corner in the very pretty village of Gerberoy in the Picardy region of France. It was an overcast day but the soft lighting was ideal for this close-up shot, which appealed to me because of the rich colours and textures of the stone and foliage.

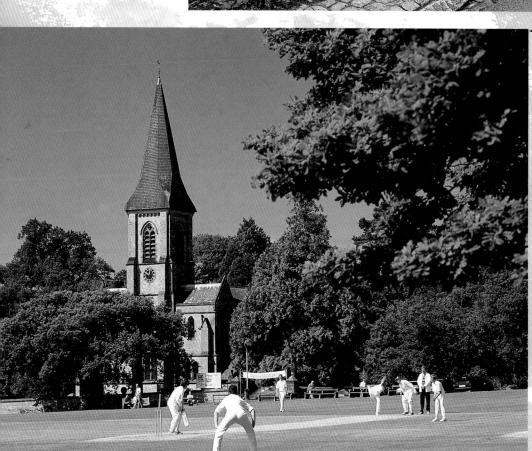

warm-up filter and Fuji Velvia.

Technical Details

Medium-format SLR Camera with a 55—105mm zoom lens, an 81A

Technical DetailsMedium-format SLR Camera with a 210mm lens, 81C warm-up and polarising filters, yand Fuji Velvia:

Countryside & Villages

Seeing

I always think that the late autumn is the best time to visit and photograph the Countryside and this is especially true of wine country when the vines turn this wonderful colour of burnished gold. It's seldom bettered than in the Champagne region of France where this picture was taken.

Thinking

I wanted to show as large an expanse of the vines as possible and decided to look for a high viewpoint which would enable me to look down the vine rows to the distant plain.

Looking across the vine rows usually results in a rather featureless expanse of colour.

Technical Details. Medium-format SLR Camera with a 50mm wide-angle lens, 818 warm-up and polarising filters, and Fuji Velvia.

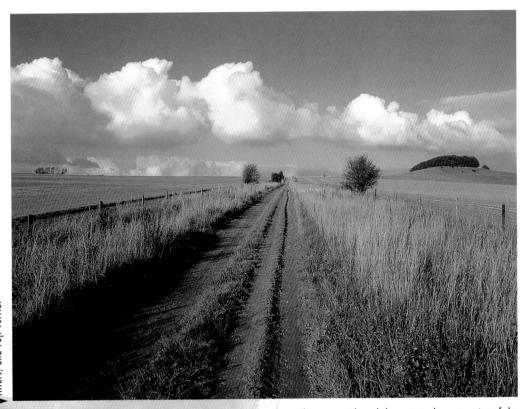

Walking is one of the most popular and enjoyable ways of experiencing the countryside and this picture shows a section of the Ridgeway, one of the best-loved long-distance tracks in England. It was a crisp, early-winter's morning and the sunlight was at a low angle, sharp and clear. I liked the 'V' shape created by the grasses lining the track and the way the latter disappeared into the distance — I thought it looked inviting. I chose a viewpoint just to one side of the track's centre and used a wide-angle lens to heighten the perspective effect and give a strong feeling of depth and distance.

Technical Details

▼35mm SLR Camera with a 75—300mm zoom lens, 81B warm-up, neutral-graduated and polarising filters, and Fuji Velvia.

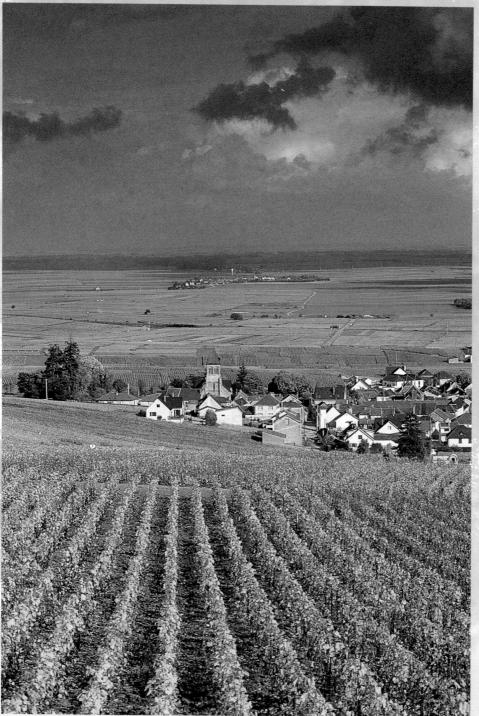

Acting

From this spot I found that I could achieve this and also include the village which I thought would provide an effective focus of interest for the composition, I also chose to include a generous area of the Grey Sky to balance the composition and enhance the effect of the golden vines, so I used the upright format, placing the village just below the centre of the frame. Using the landscape shape for this scene would have meant including much less of

the sky and foreground and would have diminished the effect of the picture.

Rule of Thumb

Using a wide-angle lens and a viewpoint which includes close foreground details will help to produce pictures which have a three-dimensional quality and a feeling of depth, but you must use a small aperture if you want both foreground and horizon detail to be sharp.

Countryside & Villages

Seeing

I spotted this old cottage in the village of Gerberoy in France late one afternoon and was attracted by the way the light glanced along the cobbled street creating a rich texture.

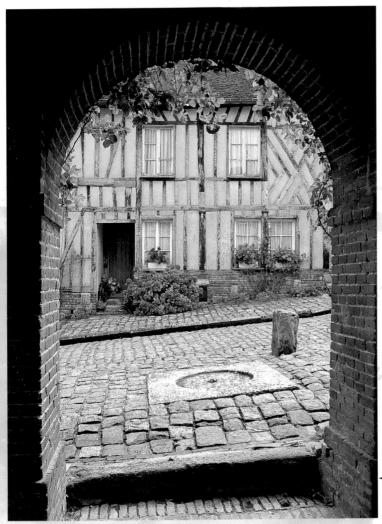

Thinking

Although the houses beside the cobbles were very pretty they were in ShadOW and I felt that another element was needed to create a Strong Image. I therefore looked for a viewpoint that would allow me to include some foreground interest.

Acting

Opposite the houses was a small covered-market hall and I found that by setting my camera up just INSIDE it, and using a wide-angle lens, I was able to include enough of one of the archways to act as a frame around the cottages, which gave the image that extra edge it needed.

Rule of Thumb

The warm, mellow sunlight early or late in the day is ideal for photographing buildings, especially those built of ancient stone and weathered wood, as it enriches the colour and enhances the texture.

Technical Details

Medium-format SLR Camera with a 50mm wide-angle lens and an 81A warm-up filter. The village of Labastide d'Armagnac is one of the most photogenic mediaeval villages in France with a central square surrounded by ancient houses, stone arcades and a fine old church. I took this picture early on a Sunday morning when few people were around. I chose this viewpoint as it gave me a pleasing perspective on the fronts of the houses and also, by using a wide-angle lens, allowed me to include some of the arcade as foreground, helping to create a feeling of depth in the picture as well as adding interest to the composition.

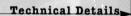

Medium-format SLR Camera with a 50mm wide-angle lens, 81B warm-up and polarising filters, and Fuji Velvia.

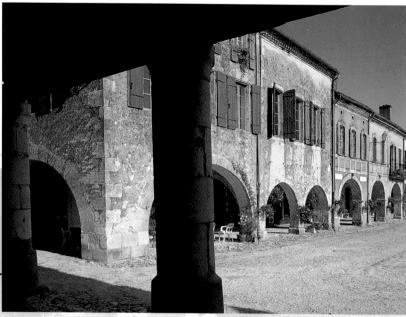

This autumnal landscape was photographed in the Gascony region of France, and the field in the foreground is of sunflowers which have died off and are waiting to be harvested. It had been a dull, overcast day and it was not until a short while before sunset that the sun began to make a weak appearance. It broke through the cloud just enough to create this subtle colour in the sky which together with the autumnal colours created an almost old-fashioned, sepia effect.

Technical Details

Medium-format SLR Camera with a 55-110mm zoom lens, 81A warm-up and neutral-graduated filters, and Fuji Velvia.

Trains, Boats & Planes

Travel is an almost inevitable part of a vacation. In some cases it is just something which has to be put up with in order to get to the destination, in other instances it is an integral part of the holiday, and, quite often, the journey itself is the main purpose of the trip. Whichever the case, a photograph or two which captures the experience of travelling invariably adds an interesting and valuable facet to a holiday record.

Seeing

I spotted this old Mississippi steam boat as it was about to leave the dock in New Orleans and realised I had little time to take my picture.

Thinking

I felt it would be more interesting to have some foreground interest rather than wait until the boat left the jetty and shoot it on its own, so I hurried as close as possible to the edge of the quay.

Acting

By using a wide-angle lens I was able to place part of the jetty and the wooden support posts in the Close foreground which at the same time exaggerated the perspective of the boat and at the same time emphasised the churning paddle wheel.

Technical Details

▼ 35mm SLR Camera with a 20—35mm zoom lens, 81C warm-up and polarising filters, and Fuji Provia.

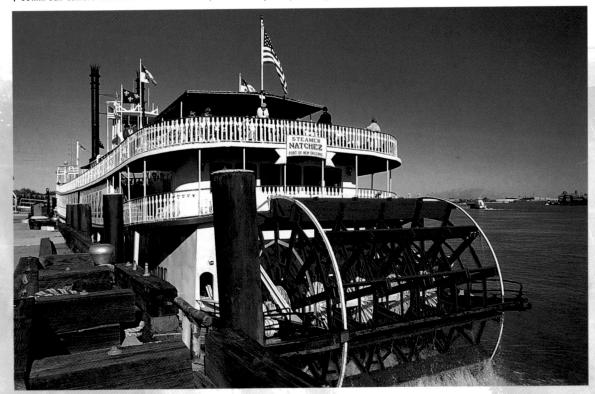

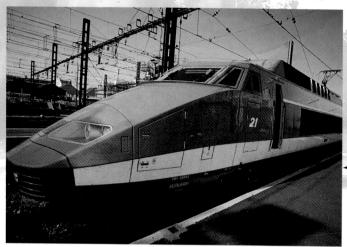

I took this photograph on a trip to Paris just after the French had introduced their TGV trains, It was late afternoon and the long shadows have contributed to the effect of the picture. I used a wide-angle lens from a very close viewpoint in order to exaggerate the perspective and to make the railway engine appear even more racy and aggressive. I framed the picture quite tightly to exclude some passengers who were visible further up the platform as I felt this would be distracting.

Technical Details

35mm SLR Camera with a 20—35mm zoom lens, an 81A warm-up filter and Fuji Velvia.

Technical Details 35mm SLR Camera with a 24-85mm zoom lens, an 81B warm-up

I was lucky to get a window seat on the best side of the plane on this occasion, i.e. facing away from the sun. I used a wide-angle lens and placed it as close to the glass as possible without touching it, and I used my fastest shutter speed. I also fitted an 81B warm-up filter to counter the strong blue cast which is created by UV light at high altitudes.

Rule of Thumb

When shooting pictures from a moving vehicle it's wise to use the fastest shutter speed which conditions will allow. It can help to pan the camera with the movement, holding your subject as steady in the frame as possible. But do resist the temptation to brace the camera against a window, when in a plane, for example, as the engine vibration can cause noticeable image blurring.

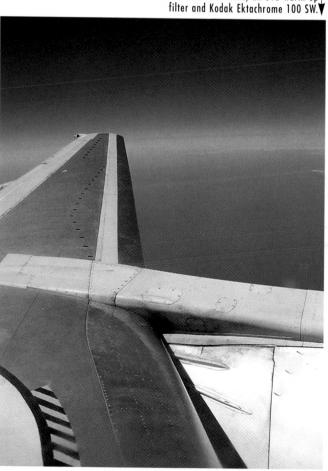

Trains, Boats & Planes

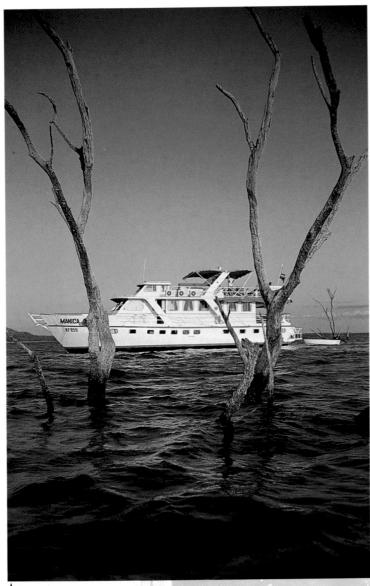

ATechnical Details
35mm SLR Camera with a 75-300mm zoom lens, an 81A warm-up filter and Fuji Velvia.

Seeing

I'd spent several days on this boat travelling along the shores of Lake Kariba in Zimbabwe. I wanted to have a picture of the boat but, again, most of the Opportunities had been in the middle of the day and the results had lacked that dramatic edge.

Thinking

On this occasion we had moored close to some of the drowned trees which were a feature of the man-made lake and I thought I might be able to use some of these in the shot.

Acting

I thought my best chance would be to shoot at first light when the sun was low in the sky and asked the skipper if he would ferry me out in the dinghy to take my shots. I soon found this viewpoint where I could frame the boat between two trees and also have a nice glancing light on the side of the boat together with a strong reflection in the water.

Technical Tip

A neutral-graduated filter will invariably improve the quality and effect of sunset shots. It enables you to give more exposure to darker foreground details without over-exposing the sky and losing its rich colour and tone.

The Kent and East Sussex railway in the UK was the location of this shot where the pleasure of travelling on a real old steam engine can still be enjoyed, albeit for a fairly short journey. This picture was taken at its terminal station in Tenterden and my viewpoint was from the road bridge crossing the line, using a long-focus lens. Shooting into the light has shown up the steam quite well and I liked the guard's leisurely pose.

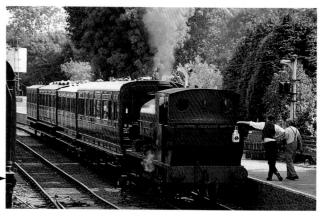

Technical Details

35mm SLR Camera with a 35-70mm zoom lens and Fuji Provia.

A Mississippi river-boat cruise was the occasion for this picture which was taken at the town of Natchez where we'd stopped for a shore excursion. I was keen to have a nice shot of the paddle boat I'd spent the week on but until now the opportunities had all been in the middle of the day and had lacked atmosphere. On this occasion we'd returned late to the boat and the sun had just set enabling me to shoot this picture fairly quickly before boarding. I was lucky not only to have such a good sky but also that the boat had been moored in front of the bridge.

Technical Details

🔻 35mm SLR Camera with a 35—70mm zoom lens, a neutral-graduated filter and Fuji Velvia.

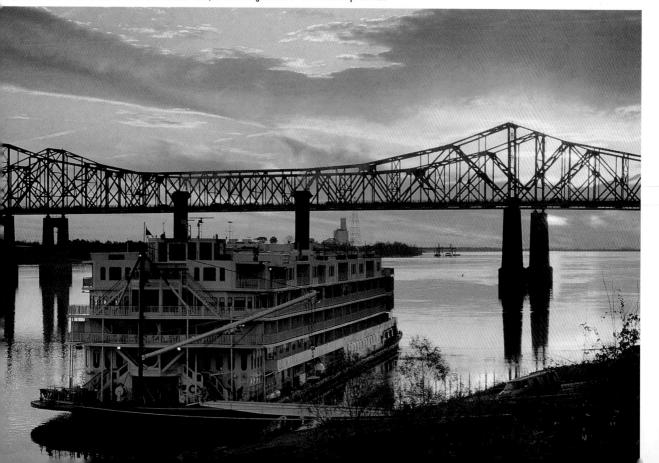

Festivals & Events

One of the pleasures of taking a vacation in foreign places is that of discovering local traditions such as festivals and other similar events. Not only can these occasions be a fascinating and memorable part of a holiday but they can also provide great opportunities for photography and will undoubtedly give the record of a holiday a dash of colour and excitement.

Seeing

I had discovered that a small IOCAI festival was taking place at a village near where I was staying in the Andalucia region of Spain and decided to go and have a look. It was very COIOUTful and the villagers had taken a great deal of trouble, dressing up in their finest traditional COStumes, and decorating their horse and ox carts.

Thinking

The event was taking place on a large area of Waste ground some distance away from the village. It was littered by parked cars and the whole scene was very untidy.

Acting

I made several attempts to shoot a WIDER VIEW of the situation but there was always something distracting and intrusive in the background. In the end I decided to fit a IONG-FOCUS IENS on my camera and simply look for EVOCATIVE details. This close-up of a glamourous flamenco dress was one of them.

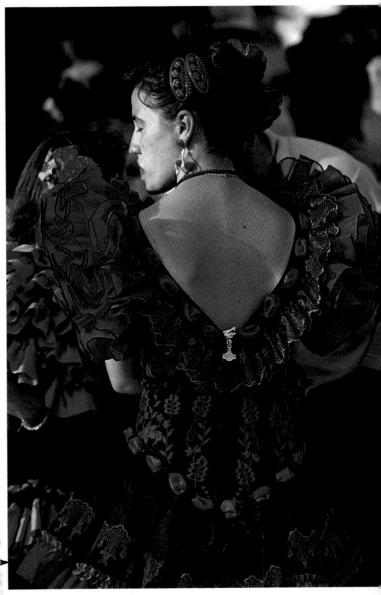

Technical Details

35mm SLR Camera with a 75—300mm zoom lens, an 81A warm-up filter and Fuji Provia.

Rule of Thumb

It's always a good idea to visit the local tourist office, town hall or information centre at your holiday destination to discover what events may be taking place during your visit. As well as the bigger annual events, more modest affairs, like a weekly market, can also be good hunting grounds for photographs and will add some good local colour to your collection of pictures.

A street parade in the Maltese capital of Valetta provided this opportunity. I had managed to push myself to the front of the crowd for an unobstructed viewpoint which gave me a sympathetic background, and then waited until an interesting float passed by. The shot was taken very late in the day as the sun was going down which has created this rather nice, warm atmospheric lighting.

Technical Details

35mm SLR Camera with a 35—70mm zoom lens, an 81A warmup filter and Kodak Ektachrome 64.

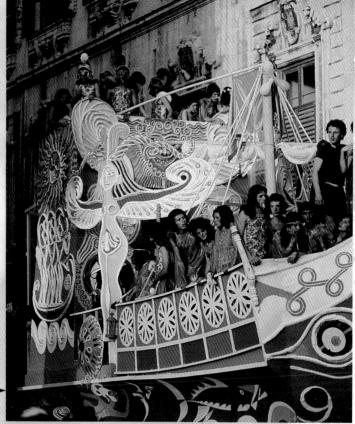

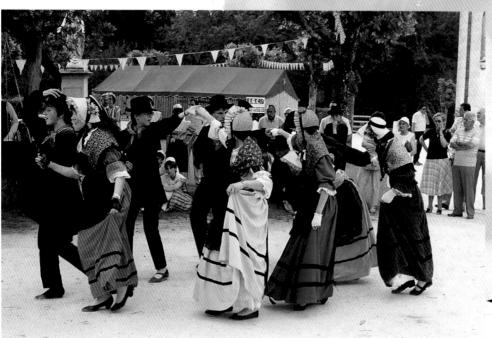

A wine fair in a French village was going on when I drove through. It was quite unexpected and because it was a small local event with no bia crowds it was relatively easy to move around freely looking for pictures. I watched this group of costumed dancers for a while and looked for a viewpoint which would give me an interesting, but not too distracting background. I used a long-focus lens to enlarge the group within the frame from a distant viewpoint and to crop out unwanted details.

Technical Details

35mm SLR Camera with a 75—300mm zoom lens, an 81A warm-up filter and Fuji Provia.

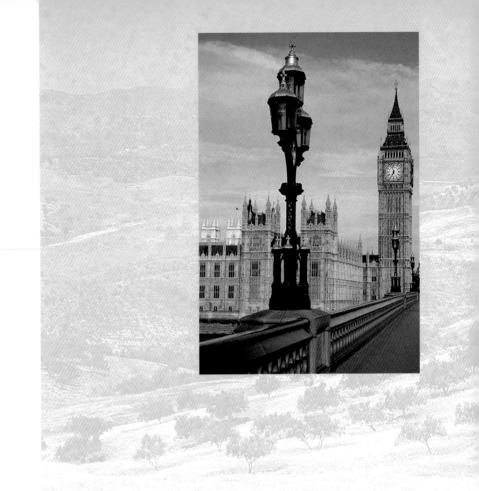

Excursions

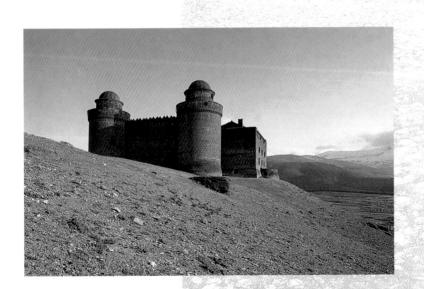

2

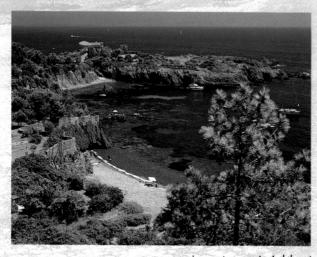

While a foreign vacation is an excellent opportunity to do very little, such as sun bathe on a beach perhaps, even then it's always a shame not to experience at least something of the

environment you are in. And there is a positive limit to the number of interesting photographs which can be taken within the confines of a beach or hotel. Many people regard a holiday as an opportunity to do many things, and making the most of outings and excursions by using your camera will help to make a complete record of a holiday and give it much wider appeal.

A Holiday Diary

It has to be admitted that even the most enthusiastic of photographers can be tempted into the "I'll do it later" philosophy when on a relaxing vacation and having a hard-earned rest. I know I am sometimes. If you succumb, this is often followed, two days before the return flight, by simply whizzing round with a hand-held camera and shooting a few "stand and smile" snaps out of sheer guilt. One way to overcome this temptation is to motivate yourself with a project, such as keeping a visual holiday diary. It is well worthwhile making a wish list of pictures you would like to have and, if you're really keen, it could begin with preparations such as looking at maps and guide books, packing the suitcase or loading the car.

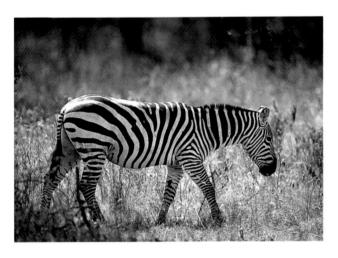

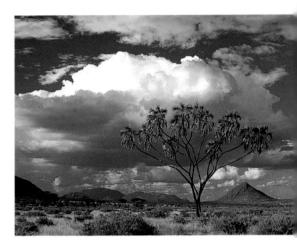

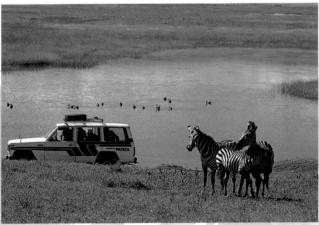

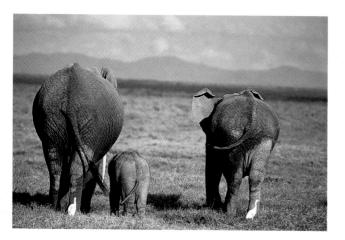

The photographs on the following three pages were all taken during a holiday in Africa when I made a conscious attempt to capture something of all the experiences the trip provided. I'm not a great devotee of the "stand and smile" approach but there are occasions when this type of shot is needed. The danger is when these pictures begin to dominate a collection.

Rule of Thumb

When taking your diary pictures try to vary the style and quality of the images. Make sure you have close-ups as well as longer shots, find ways of varying both the lighting and colour quality of your pictures, use different focal lengths to obtain a variety of perspective effects and photograph views and architecture as well as people. This will help to make your holiday diary interesting to all who see it.

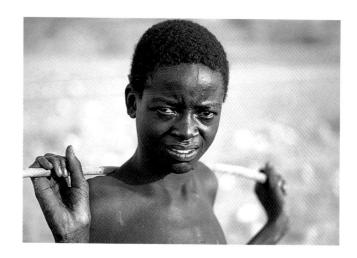

A Holiday Diary

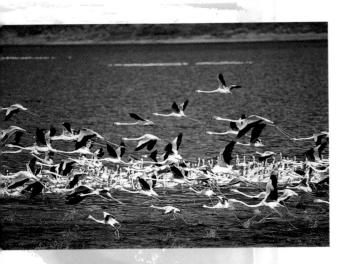

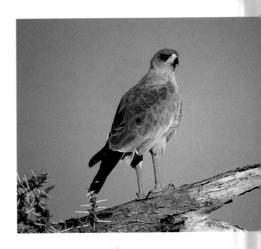

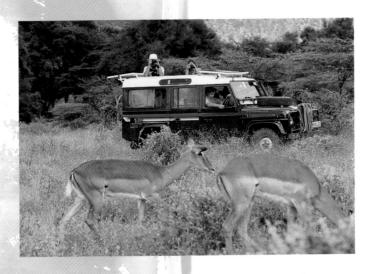

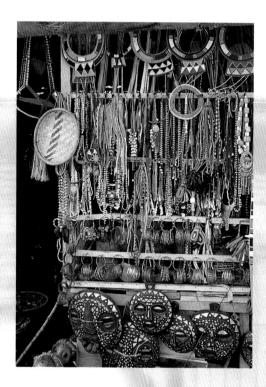

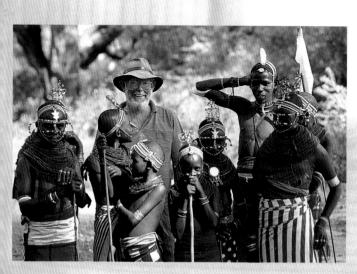

A Holiday Diary

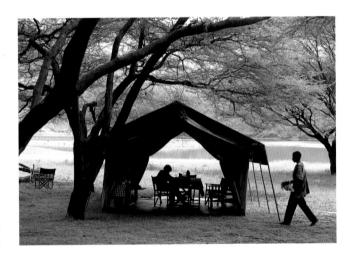

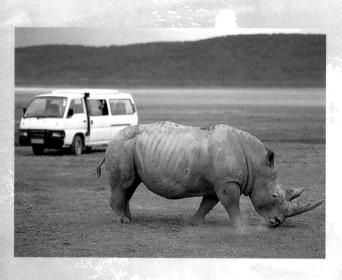

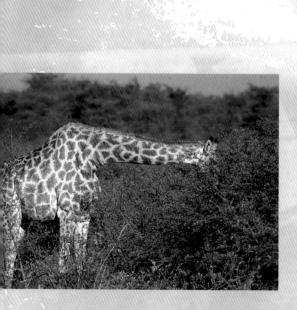

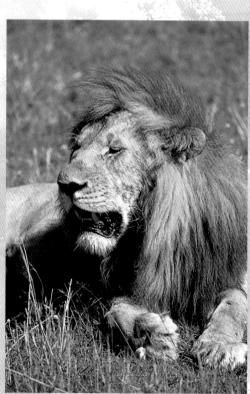

Capturing Local Colour

In these days of package holidays, big international hotels and modern developments, there are occasions when it would be easy to wake up one morning and not be sure which country you're in. It's often necessary to go out of your way to take photographs which have that elusive sense of place, those which capture something of a region's customs and style, whether it is architecture, food, fashion, advertising and road signs, or simply the faces of the people.

Seeing

This shot was taken in Bangkok's busy central market – a market is always a good place to head for if you're searching for local colour. I spent some time there walking among the stalls first of all just looking, and letting people get used to my presence.

Thinking

During this period I'd noted a few stalls which looked photogenic and had checked possible viewpoints and likely backgrounds. This particular stall was well lit and had an uncluttered background with a contrasting colour. I set my camera and bided my time.

Acting

When there was a lull in the throng of shoppers around the stall, I just asked nicely if I could take a photograph which I was then able to do quite quickly, a delay often results in people becoming self-conscious.

Rule of Thumb

When you are shooting pictures in an alien environment it pays to wait for a while until any curiosity about you wanes. It also helps to keep a low profile; — don't carry an ostentatious camera bag, and try to change lenses and films in a quiet spot out of people's sight. Be as prepared as possible before committing to a picture and always smile and be friendly.

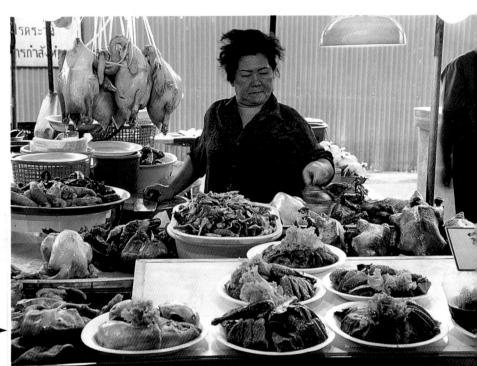

Technical Details

35mm SLR Camera with a 24—85mm zoom lens, an 81A warm-up filter and Kodak Ektachrome 100 SW.

Technical Details

▼35mm SLR Camera with a 50mm lens, an 81A warm-up filter and Kodak Ektachrome.

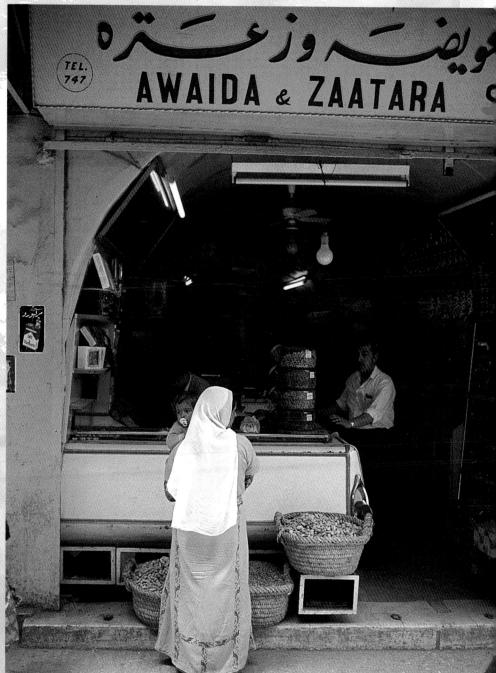

This shot was taken in the old city of Jerusalem, Israel. I'd seen this lady with her young child further up the street but the background was very untidy and distracting, so I simply followed her for a while on the other side until she stopped to look in this shop. The dark tone of the shop's interior provided a good contrasting background and I framed the image to include some of the shop's facade to act as a border. This shows how placing the woman within the darker frame of the doorway has made her more prominent and added impact to the image.

Capturing Local Colour

Seeing A busy street market on the

shores of Lake Maggiore in Italy was the location for this picture. The produce was so fresh and colourful that it made an irresistible subject. It was an overcast day but the Soft lighting had made the colours appear even more vivid and saturated.

Thinking

I considered first shooting with a longer focal-length lens and making more of a pattern picture from the display but in the end I felt it was partly the large expanse of colour which was so impressive.

Acting
I fitted a Wide-angle lens and took up a viewpoint close to the front of the stall; this exaggerated the perspective making the display seem even larger and it also prevented shoppers getting in front of me. I waited until the couple serving were in a nicely balanced **DOSITION** before shooting.

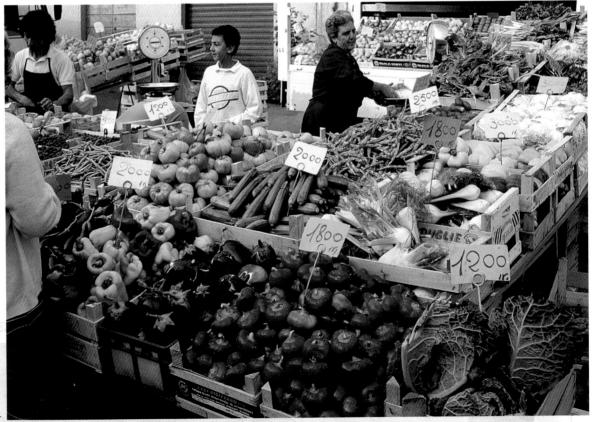

Technical Details. 35mm SLR Comero with a 20—35mm zoom lens, an 81A warm-up filter and Fuji Provia.

Trechnical Details

35mm SLR Camera with a 35-70mm zoom lens, an 81A warm-up filter and Kodak Ektachrome 64.

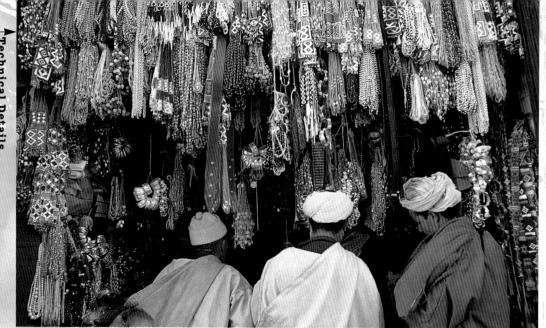

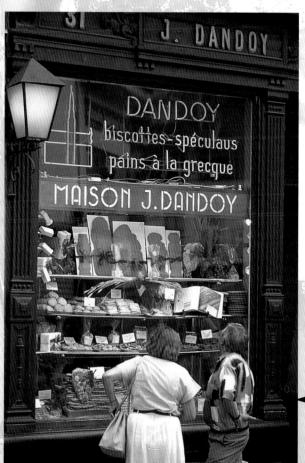

I took this picture in the souk in Marrakech in Morocco. I'd spotted the shop earlier but only other European tourists were showing an interest in the goods. I think this trio were probably also tourists but from another part of Morocco, making them look much more in keeping. I took up my viewpoint on the other side of the street and waited until they moved together into a compact arrangement before shooting. I framed the image so all of the display was included but I cropped them at waist level to avoid the inclusion of unwanted details at each side.

This was part of a series of photographs I took in Brussels for a magazine article and I was keen to illustrate some of the city's nice old shops. I was struck by this one partly because of the attractive window display and lettering but also because of the old lamp which was illuminated. Although the shop window would probably have made a good picture on its own, I felt that it would be more interesting if I included some people. I picked my viewpoint and adjusted my zoom lens to frame the image in the way I wanted and then simply waited until a likely subject came along. This couple seemed ideal because of the intent way they were studying the display. It took only a second to raise my camera and make my exposure.

Technical Details

35mm Viewfinder Camera with a 45mm lens, an 81A warm-up filter and Fuji Provia.

Capturing Local Colour

Seeing

had been wandering around the flower market near the Notre Dame in Paris when I Spotted this old lady sitting by her stall. She simply looked SO French and, in addition to the wonderful colour scheme of the scene, her manner and pose made her a must-have subject for me.

Thinking

Something about her made me feel that it might be best not to ask her permission, although I will often do this as it gives me the opportunity to plan my picture a bit more carefully, and eye contact can often add to a picture's impact.

Technical Details

35mm SLR Camera with a 75-150mm zoom lens, an 81A warm-up filter and Kodak Ektachrome 200.

Technical Details

35mm Viewfinder Camera with a 28mm lens, an 81A warm-up filter and Kodak Ektachrome 100 SW.

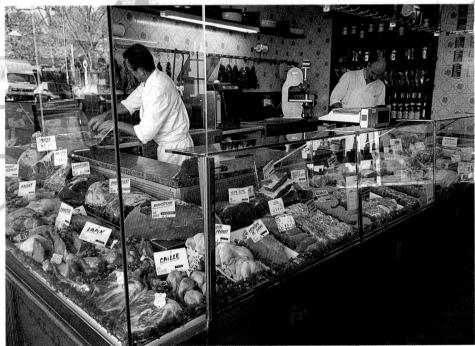

Paris and good food are virtually synonymous and this shot of a French charcuterie was. for me, a good example of local colour. The street was in shadow which made the shop lighting more dominant and helped to minimise reflections in the window. I used a wideanale lens from a viewpoint close to the window and waited until the two butchers were placed nicely in the frame before shooting.

Acting

I stayed near her for a while, taking care not to let her see me looking her way, whilst I reconnoitred the best viewpoint. Whenever she looked my way I made a play of seeming to be interested in Other people, aiming my camera occasionally in a very different direction. While this was going on, I manoeuvred myself into the spot I had chosen to shoot from, which placed the display of flowers just to one side of her. As soon as I was convinced she was engrossed elsewhere I made a few exposures, of which this was

Rule of Thumb

the best.

Shooting pictures in places like markets is invariably best done on an overcast day when the light is soft and not too directional. A sunny day can result in too much contrast in situations like these with bright highlights and sharp, dense shadows creating fussy and distracting images.

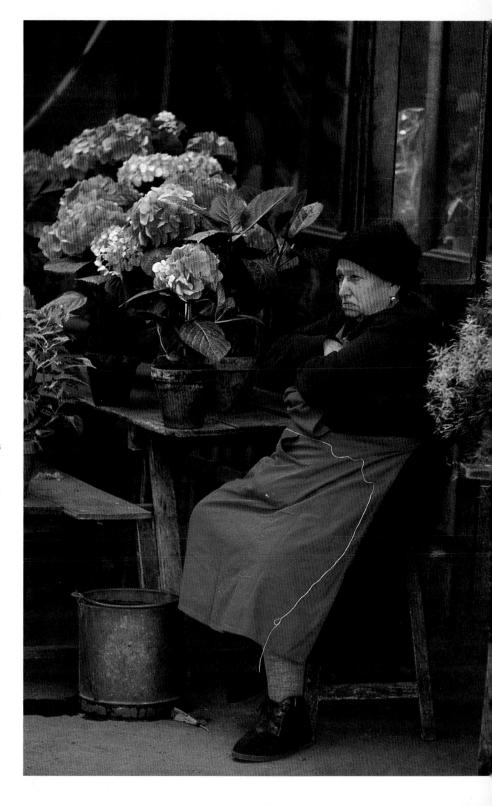

Photographing Views

Few people can resist the temptation to photograph a stunning view but the results can often be disappointing. Images like these, however, are an important part of a holiday record, whether it is of your favourite beach, an excursion into the mountains or an idyllic rural scene. The key points for success are to avoid the temptation to get too much into the frame and to only take pictures when the light makes the scene come alive.

Seeing

This small beach is along the Esterel Corniche near St Raphael in the South of France. I've been there several times and it has all the ingredients for a pleasing picture – When the light is right. On this day the light seemed near perfect. There were no clouds or haze in the atmosphere so the sea was a good rich blue and the textures of rock and foliage were well defined.

Thinking

Wide, open views like this are often best avoided unless there is real Clarity in the scene but on this occasion there was, so I looked for a VIEWPOINT which would enable me to use a wide-angle lens.

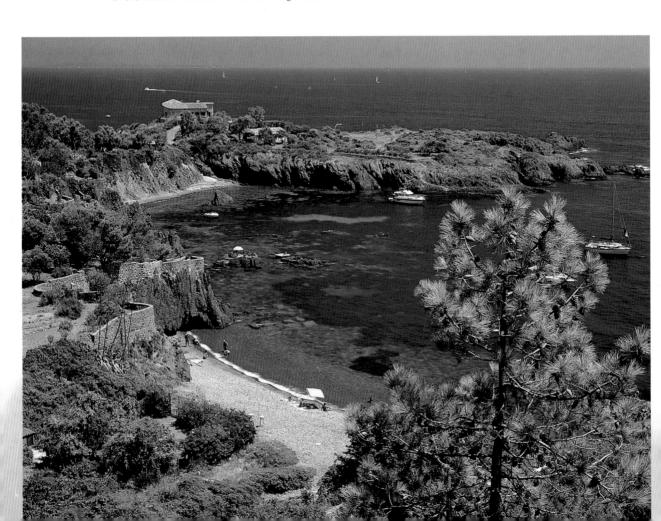

I used a long-focus lens for this picture of the Dades Gorge in Morocco, not because the light was not sharp enough for a wider view, but because the sun was low in the sky and the foreground was in deep shadow. I also wanted to frame the image tightly in order to exclude some distracting details each side of the area I photographed.

Acting

The road runs close to the beach here and I walked back along it until I found this tall pine tree. From this VIEWPOINT, I was able also to see clear to the horizon and the wide-angle lens allowed me to Include all of the small headland which juts out as well as part of the pine tree. As these elements are of a darker tone than the beach, it has resulted in the latter becoming Very dominant in the image and the Contrast has made all of the other colours seem richer. The illustration shows how the image would have been less striking, and had less feeling of depth, if the foreground tree had not been included.

Technical Details

Medium-format SLR Camera with a 50mm wideangle lens, 81C warm-up and polarising filters, and Fuji Velvia.

Rule of Thumb

You will stand a much better chance of shooting open views successfully if you plan to do it early or late in the day. At these times, the sun is at a low angle revealing stronger textures and there is less likelihood of atmospheric haze.

Technical Details 35mm SLR Camera with a 70-200mm zoom lens 818 warm-up and polarising

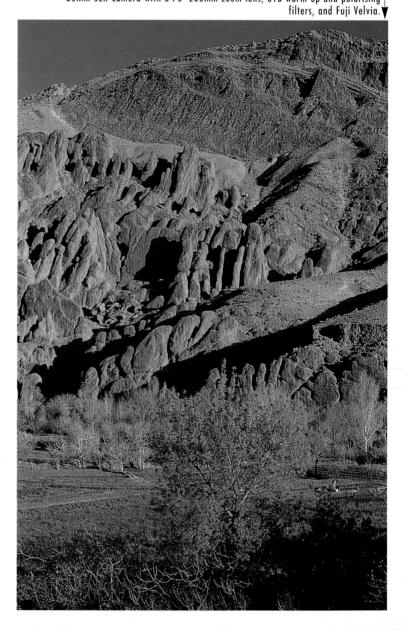

Excursions

Photographing Views

Seeing

A period of prolonged and heavy WINTER rain a couple of years ago brought an end to near-drought conditions in Spain's Andalucia, and the following spring released an astonishing display of wild flowers and lush foliage. This golden-coloured plant was covering Vast tracts of the landscape to the east of Malaga and I searched avidly for a photogenic corner.

Thinking

Although sunny, it was a bit hazy and it was also in the middle of the day which meant the shadows were small and not very well defined, resulting in a slightly soft image with not quite enough bite, especially for an open view.

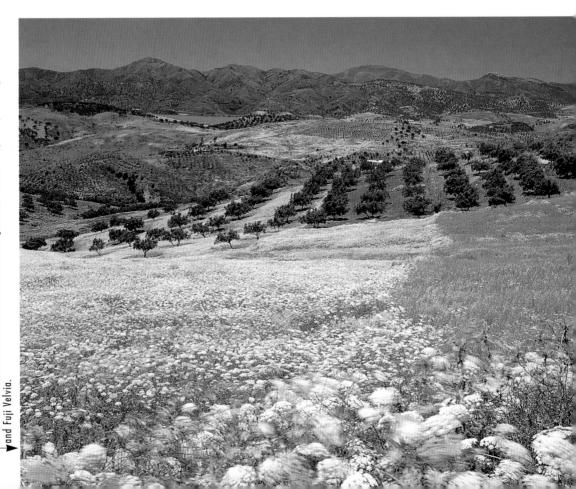

Technical DetailsMedium-format SLR Camera with a 50mm wide-angle lens, 81C warm-up and polarising filters,

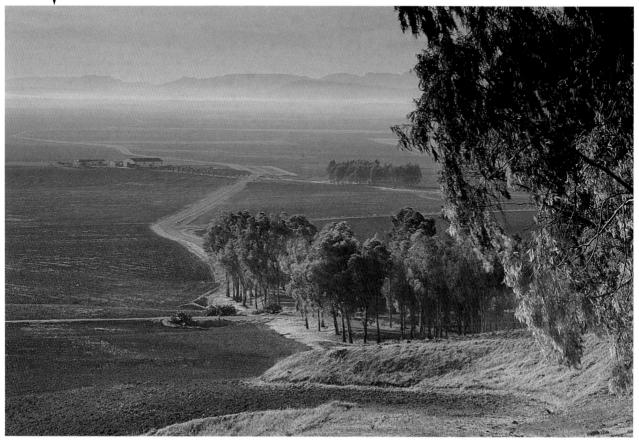

Acting

found this viewpoint up on a hillside looking down towards the Lake of Vinuela, and from here there was a quite breathtaking panorama which was dominated by the pale gold blooms. I set up my camera in a spot which enabled me to include some of the very light blooms which were close to the camera to raise the contrast of the image, as well as help emphasise the feeling of depth and distance. I framed the image to include the olive grove on the right as the red soil and dark green trees also added a degree of contrast. I fitted a polarising filter to increase the colour saturation and a warm-up filter to further enhance the gold colour.

This view of the River Guadalquivir plain in Andalucia was taken on a similarly soft and hazy day, but was photographed quite early in the morning when the shadows were quite large. In this case the haze has contributed to the atmosphere of the picture, but it needed the inclusion of the shaded trees to prevent the image becoming flat and muddy.

Rule of Thumb

Unless the sun is really bright and strong and the atmosphere free from haze, there is always the likelihood that there will not be enough contrast for a really strong image when shooting summer landscapes, especially open views. Including foreground interest which creates a strong colour or tonal contrast with the rest of the scene is often an effective way of overcoming this.

Photographing Views

Seeing

The ancient perched village of Chateau Chalon, in France's Jura region, can be seen from a long way off. The vineyards which surround the village had turned to a vivid rust and ochre and I spent some time shooting pictures from a viewpoint below the village before driving up to see how things looked from there. It was early on an Autumn morning and the light was sharp and clear and, although I lost the benefit of the rich-coloured vineyards, the texture of the village houses and distant landscape more than compensated.

Thinking

My main concern was to Include as much of the village as possible but also to show as large an area of the distant view as possible. However, the lower section of the landscape was still in shadow and I decided to wait a little until the sun rose high enough to light it more fully.

► Technical Details

35mm SLR Camera with a 70-200mm zoom lens, 81B warm-up and polarising filters, and Fuji Velvia.

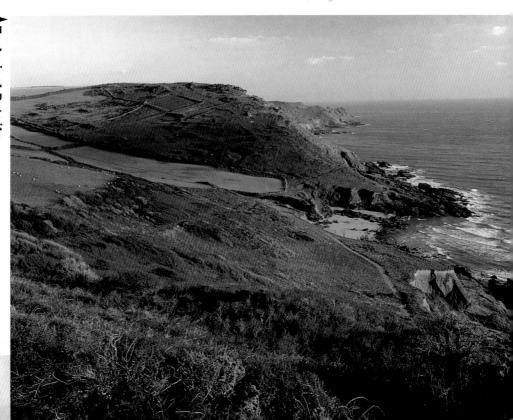

Acting
I chose this VIEWPOINT as it
provided a good view of the
village and an acceptable amount
of the landscape beyond. I framed
the image initially as a
landscape shape as
this included more of the view but
when I tried it as an Upright I
felt that, although less was
shown, it created a more compact
and balanced composition.

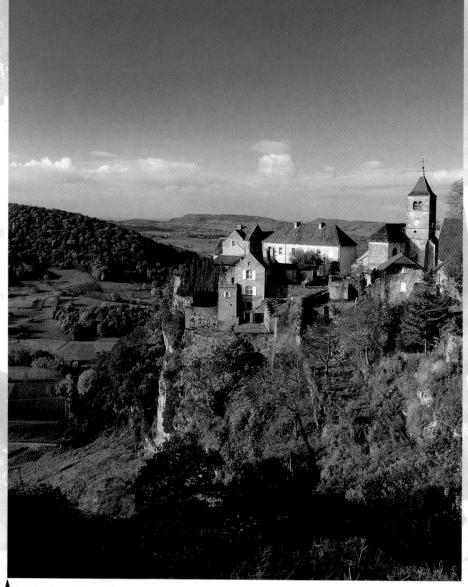

↑Technical Details

Medium-format SLR Camera with a 50mm wide-angle lens, 81A warm-up and polarising filters, and Fuji Velvia.

Gara Rock in the South Hams region of Devon in the UK was the location of this picture. It was taken late afternoon on a winter's day when the warmtinted sunlight emphasised the rich red colour of the dead bracken. I chose a viewpoint which showed a good stretch of the coastline, using a wideangle lens, and framed the image to include enough of the bracken-covered hillsides to balance the composition.

Rule of Thumb

Photographs are often taken in the landscape format when an upright framing would create a better composition. This is partly because it is easier and more comfortable to hold most cameras in the horizontal position. It can be helpful to adopt the habit of always looking first at the upright possibilities when initially framing a shot and in this way you won't overlook the chance of a stronger image.

Photographing the Sights

Famous sights and well-known landmarks must account for a large proportion of the photographs people take when travelling on vacation. Quite a few of these are of the variety where a companion is pictured with a famous sight behind them, but apart from providing evidence on the "Been there, done that" level there has always seemed little point in it to me. Far better, I would think, to take away a picture as a souvenir which was personalised more by being an original or appealing image of a place. These also have the benefit of being of much greater interest to others who look at them.

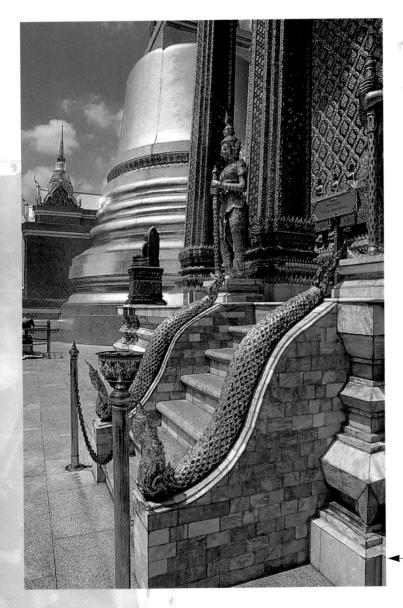

Seeing

The Grand Palace in Bangkok is top of the hit list for tourists and I made the MISTake of not going there first thing in the morning, so by the time I arrived it was teeming with people. The sky was also rather hazy and consequently the scene lacked the sharpness and Clarity I would have liked.

Thinking

Because of this I decided to try looking for shots of More Selective areas and ones which showed some of the detail and texture of the palace buildings.

Acting

I used a wide-angle lens and VIEWPOINT close to this foreground of the steps, limiting the area into which passing visitors could stray into my frame. This exaggerated the perspective and enhanced the three-dimensional quality of the image.

Technical Details

35mm SLR Camera with a 24—85mm zoom lens, an 81A warm-up filter and Fuji Velvia.

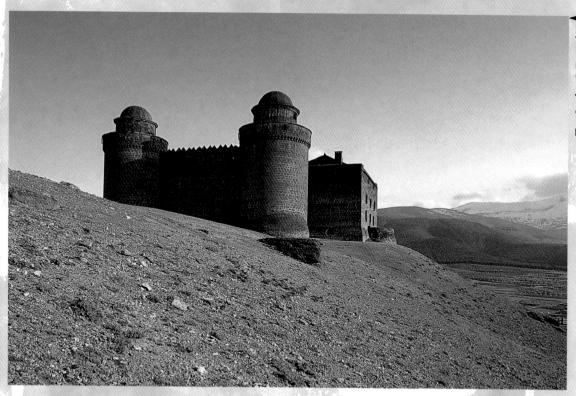

This is the castle of Lacalahorra in Spain's Andalucia. It's perched on a hilltop above a village of white houses and this is how it's usually pictured in guide books and postcards. I arrived there late one afternoon and climbed up to the castle to find that the warm sunlight was turning the stone of the castle walls a rich colour which contrasted quite strongly with the deep blue sky. I found that from this viewpoint I could avoid including any other details and this gave the place the remote and isolated atmosphere I imagine the occupants once had.

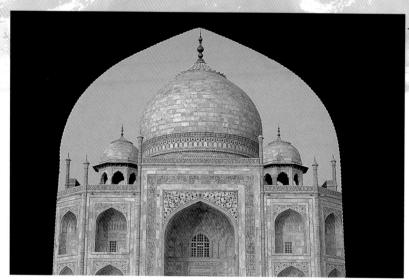

Technical Details

35mm SLR Camera with a 35—70mm zoom lens, an 81A warm-up filter and Fuji Velvia.

The simple expedient of photographing the side of the Taj Mahal, in India, and using a doorway as a frame to the image makes this shot a little less familiar than most.

Photographing the Sights

Seeing

A friend recommended a hotel in Sydney, Australia, when I told him I'd planned to visit. He said it had a GOOD VIEW of Sydney Harbour Bridge. He was not wrong. The first of my three days' stay, however, was very Grey, Cloudy and rainy with no opportunity to make use of my bedroom window

viewpoint. The second day had a brief period of Sunlight in the afternoon and I made use of that, but the shot was nothing very special.

Thinking

There are so many good photographs of this bridge that I almost felt inclined to not shoot It at all in spite of the heaven-sent gift of a good viewpoint. But I reasoned that it only needed a more interesting light to give me an image I could be happy with.

Acting

The sun was rising VerV early at this time of year but, in spite of harrowing jet lag, I set my alarm for 4.30 AM. Staggering to the window I was delighted to discover that the previous evening's cloud had cleared and there was colour on the eastern horizon, Liset up and waited using a wide-angle lens with my panoramic camera. This format was ideal as both the sky and the water became black very quickly further from the horizon and would have produced a large, featureless area on a standard landscape.

Technical Details

▼35mm Viewfinder Camera with a 45mm wide-angle lens and Fuji Velvia.

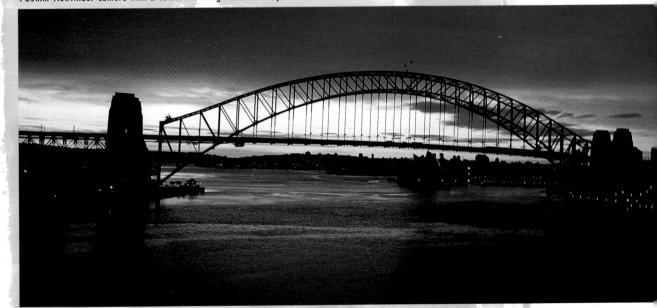

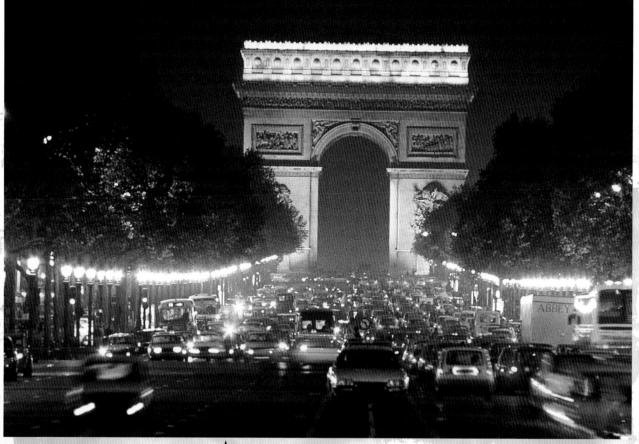

Technical Details
35mm SLR Camera with a 75-300mm zoom lens, an 81A warm-up filter and Kodak Ektachrome

Rule of Thumb

There's often a desire when shooting famous sights to try and include all of the structure and this is where the choice of viewpoint and even the lighting can be a very restricting factor. Instead, if you consider the building or monument to simply be something of which you can use as little or as much as necessary to make a satisfying image, you will find that this can give your pictures a more interesting quality than would a straightforward architectural record.

The problems of obstructions such as crowds of people and parked cars can often be overcome by shooting at night when a building is well illuminated. This picture of the Arc de Triomphe in Paris was taken from a road island in the middle of the Champs Elysées, using a long-focus lens to enlarge the most effective part of the scene. I used a tripod to support the camera for the necessary exposure of several seconds.

Photographing the Sights

Seeing

I had visited the Victoria falls in Zimbabwe during the afternoon of the previous day and had been mightily impressed – it's a truly awe-inspiring sight – but recognised that this was not going to translate into an even moderately interesting photograph at that particular time, as it was Cloudy and the viewpoints were very limited at this point of access.

Thinking

I was moving on the next day with the group I was accompanying but thought I would have time, and that it might be worthwhile, to go Very early again to the falls before the sun rose, and shoot if the Sky looked clear.

Acting

At 4.00 AM there was not a cloud in the sky and I set off, arriving at this VIEWPOINT ten minutes or so before the sun lifted above the artificial horizon of the falls. I shot a few pictures at this time and they were quite pleasing but decided to Wait to see where the sun would rise. As you can see, it rose blindingly bright directly ahead of me and I fitted a wide-angle lens and a neutral-graduated filter to tone it down a little and made a few exposures. In less than a minute or so the sun was far too bright causing flare and obliterating the rest of the scene. At this point I was not really sure if I had anything WorthWhile, but on processing the film I felt that there was just enough sense of the mass of cascading water and the colour and atmosphere of sunrise to make it work.

_**Technical Details**__ ▼35mm SLR Camera with a 20-35mm zoom lens, a neutral-graduated filter and Fuji Velvia.

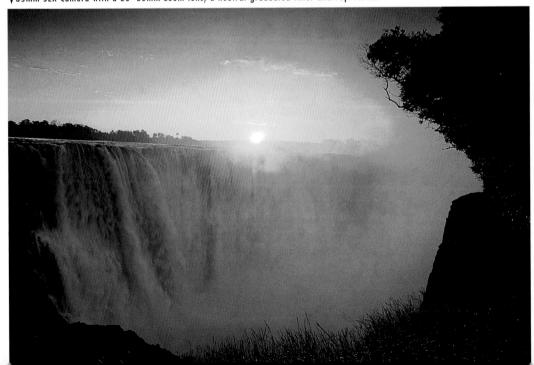

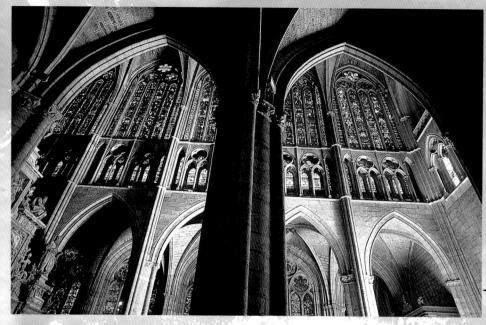

I photographed this section of the interior of the Cathedral of Leon in Spain using just natural light, choosing a viewpoint and framing the image to exclude any very bright or very dark areas.

▼**Technical Details**35mm SLR Camera with a 20-35mm zoom lens and Fuji Velvia.

Technical Tip

When shooting into the light there is a strong possibility that the camera's exposure meter will read the scene as being much brighter than it really is, especially when the sun is included in the image. This will cause underexposure if not corrected. The best solution is to take a close-up reading from a mid-grey tone in the foreground of the scene or to increase the exposure indicated by a normal average reading by between one and three stops depending on the brightness of the back-lighting.

Shooting very early in the morning is often well worth the effort when photographing well-known places. Firstly, it overcomes the problem of crowds of sightseers — few are around before breakfast — and secondly the warm colour quality of low-angled sunlight invariably enhances the colour, texture and ambience of old stone and weathered wood.

This shot of London's Big Ben was taken from a viewpoint on Westminster Bridge and I framed the picture to exclude the passing traffic.

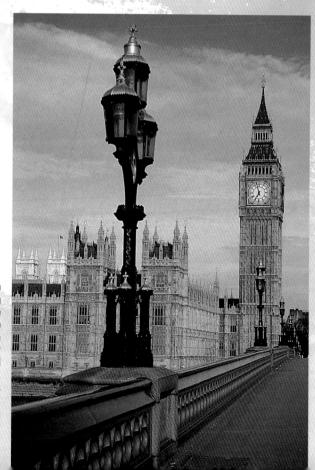

Photographing People

If you watch the prints being discharged from a one-hour photolab it's pretty evident that a high proportion of the photographs taken during a vacation are of people and the majority of these are of the participants themselves. It's quite natural that you should want to have a record of yourself and your partner or companions during a holiday break but it's a shame to let this dominate a collection of photographs. It can only add to the pleasure of a holiday record if you also photograph people you meet, local characters and anyone who has contributed to your holiday experience.

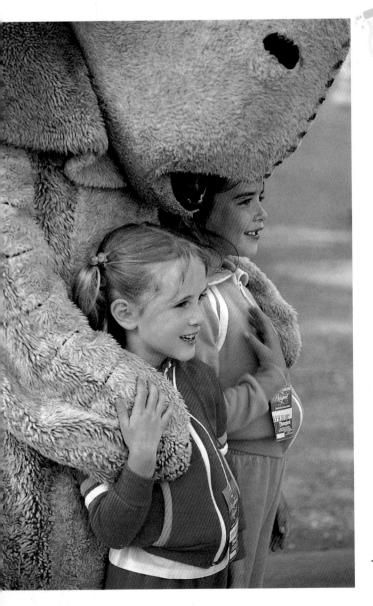

Seeing

I spotted these two young girls during a visit to Disneyland and Watched as they had their photograph taken as they posed with one of the costumed characters. The scene appealed to me partly because of the pleasing colours – soft blues, greys and pinks – as much as because of the situation itself.

Thinking

I wanted to find a way of making my picture different to the "stand and smile" shot I would have got if I'd shot it from where their parents were taking their picture.

Acting

I found that by standing to the side I could see both of their expressions clearly and, at the same time, was able to use the Disney character as a frame to the image, creating a nicely compact composition. It also produced a more spontaneous, less posed effect.

Technical Details

35mm SLR Camera with a 75—300mm zoom lens, an 81A warm-up filter and Kodachrome 64. This rather glum little girl was having her face painted at a village fete and I could not resist the contrast between the seriousness of her expression and the appearance of her face. I framed the image very tightly using a long-focus lens to focus attention on her features.

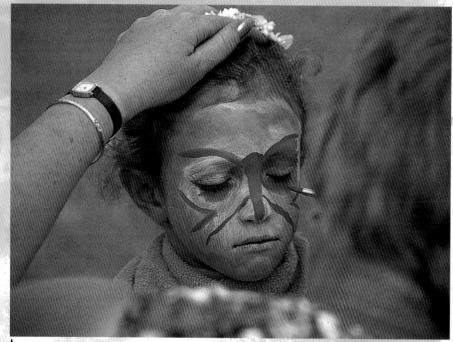

Technical Details
35mm SLR Camera with a 70-200mm zoom lens, an 81A warm-up filter and Fuji Provia.

Technical Details ▼35mm SLR Camera with a 75-300mm zoom lens, an 81A warm-up filter and Fuji Provia.

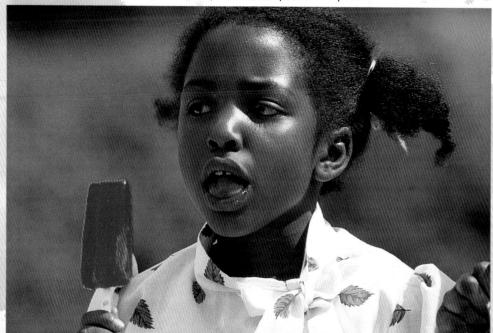

This little girl was enjoying herself at the Nairobi races in Kenya and I was taken with the contrast between her ice lolly and the rest of the image. I was in the process of framing the shot tightly using a long-focus lens when she suddenly poked out a red tongue which was just the icing on the cake for this shot.

Photographing People

Seeing

This Bedouin had been a guide on a photographic workshop I was accompanying. On this occasion, he had organised a photo opportunity in which the participants were able to shoot him and a friend riding their camels OVET the dunes in southern Morocco.

Thinking

This had provided some good moments but the early morning light was very soft and hazy resulting in the more distant shots being rather flat and lacking in sparkle. Because of this I thought that perhaps a more conventional portrait might produce a better picture.

Acting

I asked him to sit close to his camel on the Sand with his back to the sun and in a spot where the dune behind him would provide a plain, uncluttered background. I framed the image to include all of him and enough of his companion to balance the composition.

**Technical Details** √35mm SLR Camera with a 75—200mm zoom lens, an 81A warm-up filter and Fuji Provia.

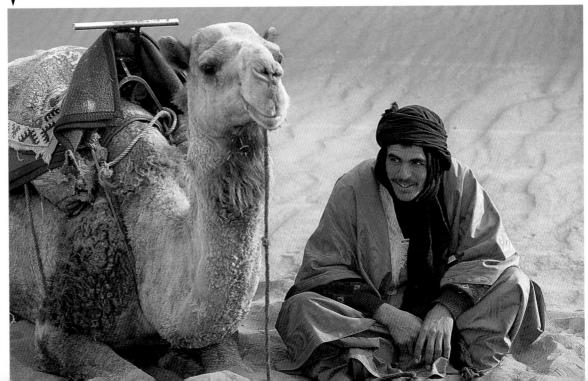

Rule of Thumb

As a general rule it is best to avoid direct sunlight for pictures of people, especially when they are quite close to the camera, as the bright highlights and dense shadows caused by sunlight can create too much contrast and be quite unflattering.

I'd had the opportunity to visit an off-the-beaten-track village in the Gambia, West Africa, where the residents were not at all accustomed to tourists, and, as a result, had a very natural and relaxed attitude to the occasional visitor like myself. This allowed me to take pictures of the villagers with their cooperation and I was able to ask them to sit in a particular spot, where the light was pleasing and there was a good background. This portrait of a mother and child was shot in open shade with soft lighting and I used a plain wall as a contrasting background.

Technical Details

35mm SLR Camera with a 75—300mm zoom lens, an 81A warm-up filter and Kodachrome 64.

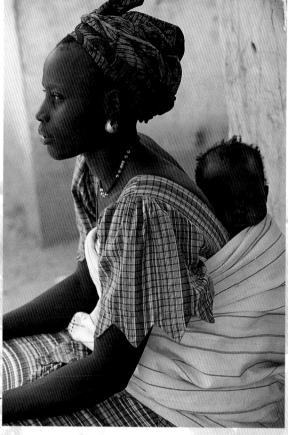

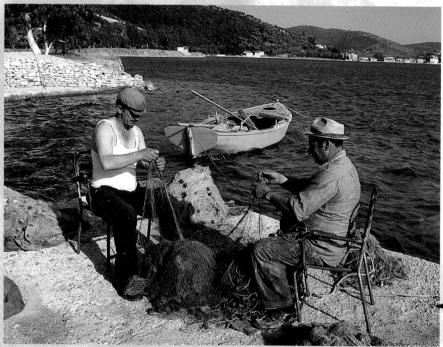

These two fishermen were mending their nets beside a small bay in the Greek island of Ithaca. After asking their permission I simply chose a viewpoint quite close to them which placed the most scenic area of the background behind them. I then used a wide-angle lens to enable me to include a fairly wide expanse of this.

Technical Details

Medium-format SLR Camera with a 55mm wide-angle lens, 81C warm-up and polarising filters, and Kodak Ektachrome 64.

Photographing People

Seeing

The village of Montehermosa in Spain's Extramadura region is known for its Unique handicrafts which have a very South American look, probably as a result of returning Conquistadors. I wanted to photograph one of the ladies wearing her traditional COStume, who was selling her handicrafts from a roadside stall.

Thinking

But shooting in this setting was almost impossible as the sunlight was harsh and contrasty and both the surroundings and background very untidy and distracting.

Acting

I asked the lady if she would mind MOVING over near the wall of a house which was IN Shade. This provided a much softer and more pleasing light and I was also able to use it as a less cluttered and more unobtrusive background. The illustration shows how the image would have been too cluttered and the subject less defined had a plain, contrasting background not been used.

Technical Details ▼35mm SLR Camera with a 20-35mm zoom lens, an 81A warm-up filter and Fuji Provia.

The streets of old Delhi in India are the home of this small family. I was a bit doubtful about approaching them for a picture as I was keen to avoid intruding on their privacy and my presence could, very understandably, cause a somewhat resentful response. But my tentative request was met with amusement, interest and even enthusiasm. Using a wide-angle lens I simply framed the image in a way that included all of the family but excluded as many of the extraneous details as possible.

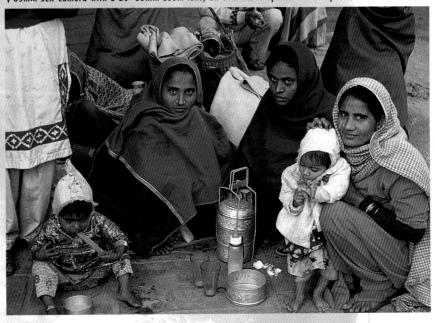

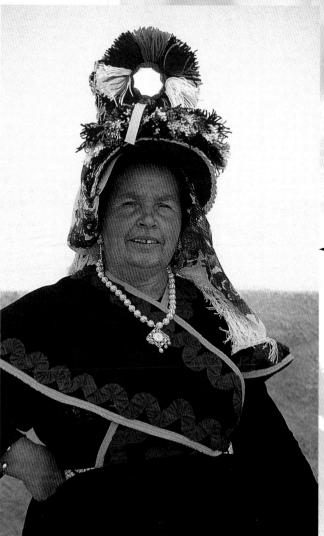

Technical Details 35mm SLR Camera with a 35-70mm zoom lens, an 81A warm-up filter and Fuji Velvia.

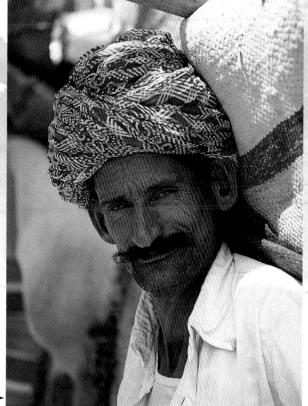

This very relaxed gentleman was taking a rest during the Pushkar Camel fair in India. Rajastahni tribesmen take considerable pride in their appearance, and, in my experience, really love to be photographed. In spite of having his rest disturbed, this man was ready and willing with a smile when he saw my raised camera. Using a long-focus lens, I simply framed the image tightly to concentrate attention on his strong features.

Technical Details → 35mm SLR Camera with a 75-300mm zoom lens, an 81A warm-up filter and Fuji Provia.

In the Frame

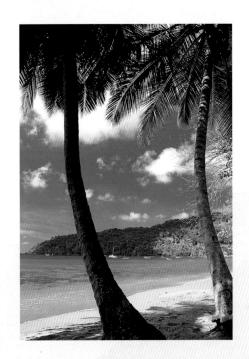

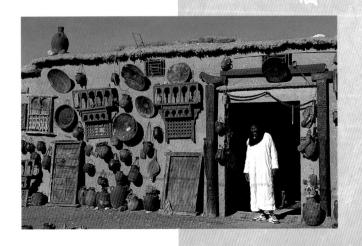

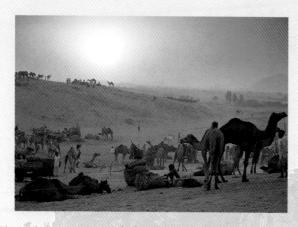

No matter how stunning a scene, how impressive a building or how characterful a subject's face, unless the image is well organised within the frame the resulting picture will inevitably

be disappointing. The viewfinder is much more than a means of aiming the camera, it is the frame within which you must decide exactly what is included and what is left out and, in combination with the choice of viewpoint and lighting, it is the way in which you can present your subject most effectively.

Choosing a Viewpoint

Many people will take a photograph from the place where they first see a subject. The camera's viewpoint is, however, one of the most important factors in determining the success of a photograph and should be the result of careful consideration. It can be surprising how much difference just a metre, or even less, can make to the composition of an image and it is always worth exploring all of the possibilities before making your exposure.

Seeing

The pretty seaside village of Collioure in France is one of the most photogenic spots on the Mediterranean coast – it's a favourite of mine and of Countless others. Once part of a thriving anchovy fleet the few freshly-painted boats which are pulled up on the small beach are now there, I suspect, for the benefit of photographers.

Thinking

My visit on this occasion was on a Spring afternoon and the sun was in a position which made this view of the old harbour-side church quite pleasing as well as lighting the boat very nicely. The only problem was there were a few people sitting on the beach which made the scene look very untidy.

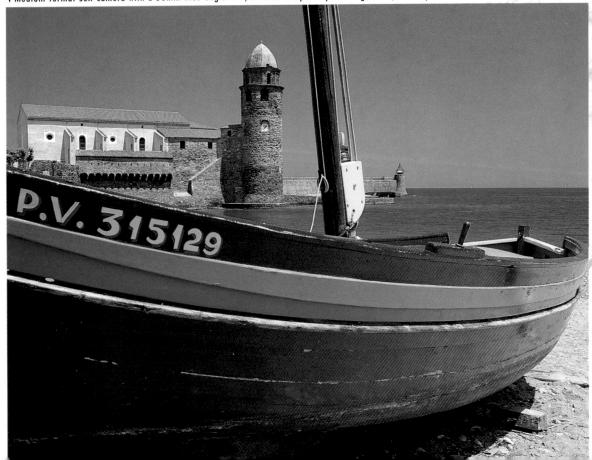

Medium-format SLR Camera with a 50mm wide-angle lens, 81C warm-up and polarising filters, and Fuji Velvia.

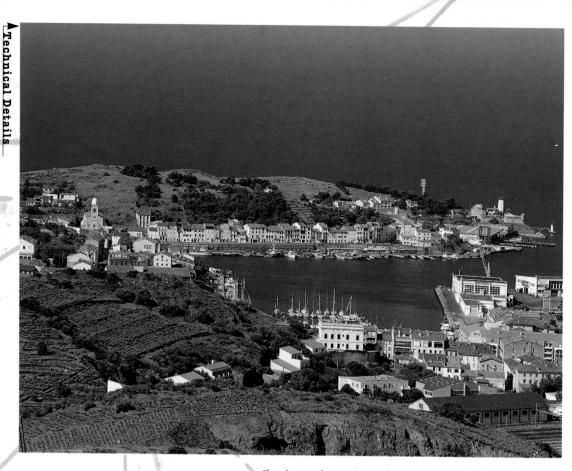

Acting

had intended to use the boat as foreground interest in any case but, on setting up my camera, I became aware that by moving half a metre or so lower than I originally planned and a little closer to it I could hide the unwanted human interest quite easily behind it. I used a Wide-angle lens to include enough of the boat in the frame and set a small aperture to ensure there was enough depth of field.

This photograph was taken on the same day a little further down the coast above the village of Port Vendres. I chose a viewpoint which placed some vineyards in the foreground to add an element of contrast and increase the impression of depth and distance, and used a polarising filter to increase the colour saturation and the clarity of the scene.

Rule of Thumb

Most photographs are taken at eye level from a standing position, because this is what is most comfortable. But often a slightly lower or higher viewpoint can make a considerable difference, especially when there are objects close to the camera and when a wide-angle lens is being used.

Choosing a Viewpoint

Seeing

I was travelling through the hill country in Sri Lanka in a region where tea is widely grown. The patterns created by the rows of terraced bushes were the thing which first struck me and so too did the rich green colour of the landscape.

Thinking

My first thought was to look for a feature within the plantation such as a hut or some tea pickers which could act as a focus of attention within the image but there was nothing which seemed interesting enough. I then became aware of the striking contrast which the red-soil pathways created in between the bushes.

Technical Details

▼35mm SLR Camera with a 35—70mm zoom lens, 81B warm-up and polarising filters, and Fuji Velvia:

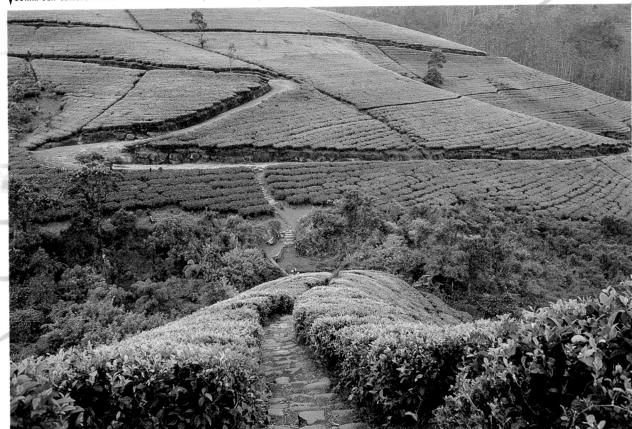

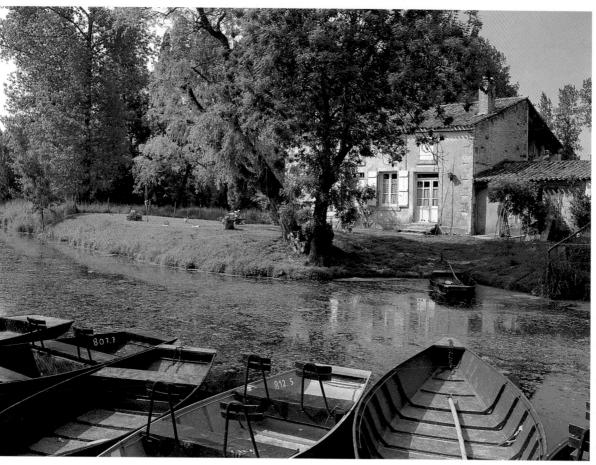

My choice of viewpoint for this shot, taken in the Marais Poitevin region of south-west France, was largely determined by my wish to include these boats in the foreground. This has added both to the atmosphere and interest of the picture as well as enhancing its three-dimensional quality. I used a small aperture to ensure that the details in both the nearest and furthest parts of the scene were recorded in sharp focus.

Acting

I found a VIEWPOINT which made one of the paths come directly towards the Camera and, at the same time, showed it ZIG-Zagging away into the corner of the frame. It was overcast and raining at the time and I framed the image to exclude the pale sky which would have detracted from the strong effect of the green foliage.

Rule of Thumb

The effect of perspective in a scene is the result of both the choice of viewpoint and of the focal length of the lens being used. When a wide-angle lens is used with objects close to the camera as well as far away the perspective will be exaggerated, increasing the impression of depth and distance. Contrarily, when a long-focus lens is used from a more distant viewpoint the effect of perspective will be diminished, producing an image with a more two-dimensional quality.

Choosing a Viewpoint

One of the numerous small beaches on the Caribbean island of Tobago was the location for this shot. The scene appealed to me because the Sunlight was crisp and there was a good blue sky with some beautiful white clouds.

Thinking

The angle of the sunlight meant, however, that the scene was lit much more pleasingly when viewed in this direction and this narrowed down my choice of viewpoint considerably. I also wanted to have some foreground interest as, no matter how stunning it is, an empty, featureless beach seldom makes a Satisfying photograph.

Technical Details

▼35mm SLR Camera with a 24-85mm zoom lens, 81C warm-up and polarising filters, and Fuji Velvia.

A journey through South Australia's outback country led to this shot. I wanted to capture something of the remoteness of the countryside and the emptiness of the roads. Although you could be forgiven for thinking that not much changed in many miles of driving I chose this particular viewpoint for a number of reasons. Firstly, I liked the fact that the distant curve in the road made it seem to disappear. Secondly, from here the mountain range was ideally placed in relation to the direction of the road, and finally the cloud formation seemed particularly impressive at this point. I framed the shot so that the horizon was placed along the lower third of the frame in order to make the most of the sky.

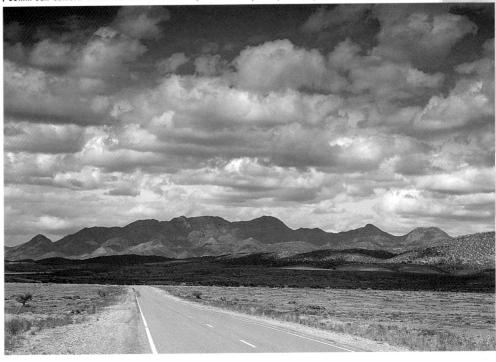

Technical Details

▼35mm SLR Camera with a 24-85mm zoom lens, 81C warm-up and polarising filters, and Fuji Velvia.

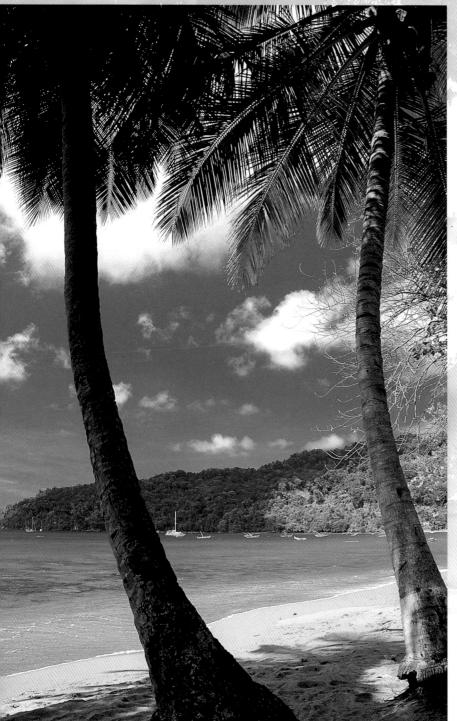

Acting

These two partially SIlhouetted palm trees at the edge of the beach were ideal and I opted to use the upright format in order to emphasise their elegant curving trunks and to include the clouds at the top of the frame. I made a final, fine adjustment to the VIEWPOINT to reveal the small white boat in the distance and also to hide a rather ugly shack on the hillside behind the left-hand palm tree.

Rule of Thumb

There is an easy way of remembering how a change of viewpoint will affect the objects on different planes within an image. If you move to the right, objects close to the camera will appear to move to the left in relation to distant details, and vice versa. If you move further from your subject it will appear to become smaller in relation to more distant objects — and vice versa — but they will also be shown closer to their true relative sizes.

Composing the Image

Having decided on a viewpoint the next step is to decide just how much of a scene should be included in the frame and how much

should be left out. It may well be that this decision may lead to the need to make a change in the viewpoint but it is being aware of this relationship between viewpoint and the way the image is framed which is the key to creating an eye-catching composition.

Seeing

The island of Burano in Italy's Veneto region is an extremely colourful place where every house seems to be painted a different, and Very bright, colour. This row of houses alongside a small canal is one of the most photogenic corners and I arrived just as the sun had moved high enough in the sky to begin glancing along the front of the houses.

Thinking

I began with the thought of adopting a More frontal angle on the houses but this meant a more distant viewpoint which included too many obtrusive details on the canal side. On taking up a viewpoint much closer to the edge of the quayside and looking along the row of houses at a More acute angle, I found the diagonal line this created gave the composition more life.

Acting

From this viewpoint, however, I needed to use a Wide-angle lens and this created too much empty space on the left-hand side of the frame. It was then that I considered using the panoramic format which has cropped the image MOre tightly at the top and bottom of the frame, making the image more compact and eliminating the excessive amount of Sky and quayside on the left of the picture.

Technical Details

▼35mm Viewfinder Camera with a 45mm wide-angle lens, 81B warm-up and polarising filters, and Fuji Velvia.

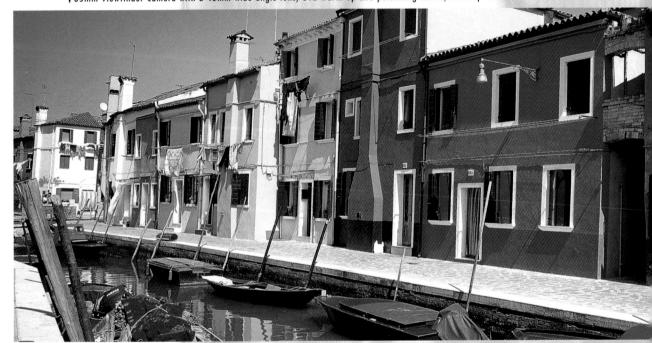

Technical Details

Medium-format SLR Camera with a 50mm wide-angle lens, 81B warm-up and polarising filters, and Fuji Velvia.

I saw this tranquil scene in the region called La Grande Briere in western France, a web of lakes and reed-lined creeks with a rather mystical atmosphere. I arrived there early one morning to find the water absolutely motionless and the sun had just climbed high enough to begin illuminating this collection of moored boats. I chose my viewpoint to look along the row towards the single, brightly painted vessel which has created a focus of attention. I used a wide-angle lens and set a small aperture to ensure there was enough depth of field.

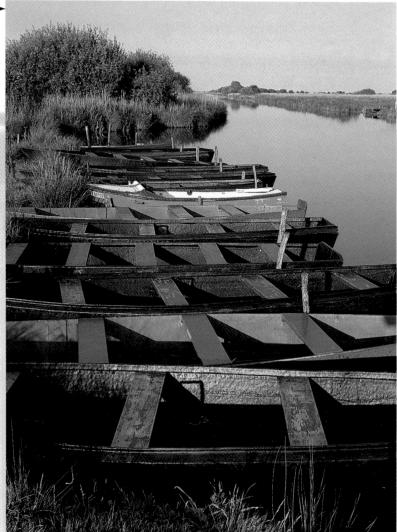

There is seldom just one best way of composing an image and an inherently photogenic scene can invariably be framed in a variety of ways. You can learn a great deal about composition by shooting a few

in a variety of ways. You can learn a great deal about composition by shooting a few variations and then comparing the results; you may well find that the shot you thought would be the most successful is sometimes bettered by another.

Rule of Thumb

Composing the Image

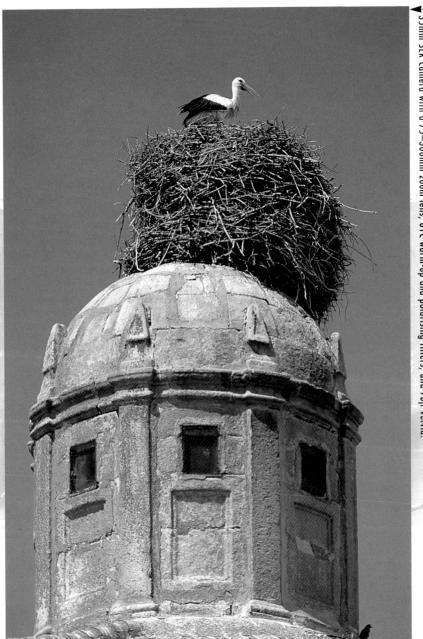

Technical Details35mm SLR Camera with a 75—300mm zoom lens, 81C warm-up and polarising filters, and Fuji Velvia

Storks' nests are a common sight in Spain during the summer; at times it seems that almost every church tower has one. This shot was taken near Avila in the village of Piedrahita. I was lucky to to find such a good nest perched upon such an attractive tower and lit so nicely, and I only had to wait a short while before the stork appeared. I simply used a long-focus lens to frame the image as tightly as possible, including just enough sky around the subject for comfort.

Rule of Thumb

It is very easy when using the viewfinder to concentrate so much on aiming the camera accurately at the main subject that you are not fully aware of all the other details which are being included. This often results in the subject seeming smaller in the picture than you originally thought. It's a good habit to always check around the edges of the frame before shooting.

Seeing

An antique store Moroccan-style, I came across this extraordinary

emporium near the town of Zagora in southern Morocco and was charmed by both the store and its proprietor, (who was a worldclass salesman)

Thinking
He readily agreed to stand in the doorway while I photographed the shop front, I placed him there because the dark interior made his white robe Stand Out very clearly.

Acting I decided to frame the image so that he appeared in the right-hand quarter of the frame and the DOt perched on the roof occupied the very top left-hand corner. I felt that these two elements balanced each other quite nicely

Technical Details

▼35mm SLR Camera with a 20—35mm zoom lens, 81C warm-up and polarising filters, and Fuji Velvia.

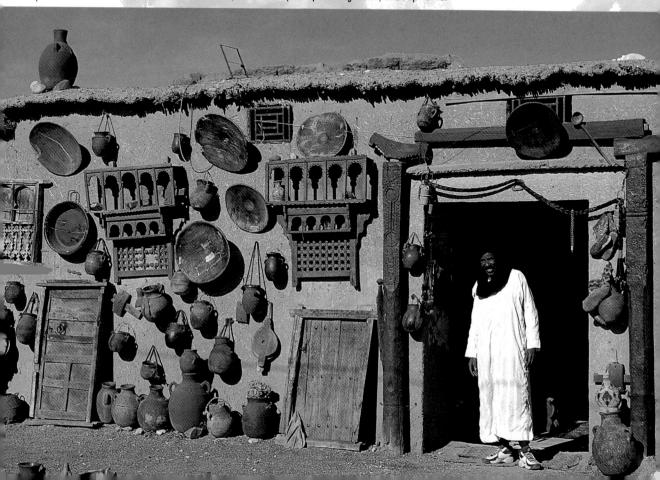

Composing the Image

Seeing

This pretty painted cottage is in the village of Gerberoy in the Picardy region of France, a place famous for its roses, and where a rose festival is held each June. My attention was caught by the Striking contrast between the bright blue timbers of the cottage and the rich red of the rose bush.

Thinking

It was a heavily OVErCast day and had been raining but the soft light enhanced the rich COlours of the subject. However, the sky was white and I looked for ways in which I could exclude it but still show a large area of the scene. My first thought was to shoot from quite square-on to the right-hand wall of the cottage and frame the image tightly. This worked quite well but I felt that not enough of the scene was being seen to show the charm of the small house.

Acting

By fitting a wide-angle lens and taking up a VIEWPOINT quite close to the corner of the building, I found I was able to include a much larger area of it and still Crop Out the sky. This more interesting angle with its diagonal lines also gave the composition a rather more dynamic quality.

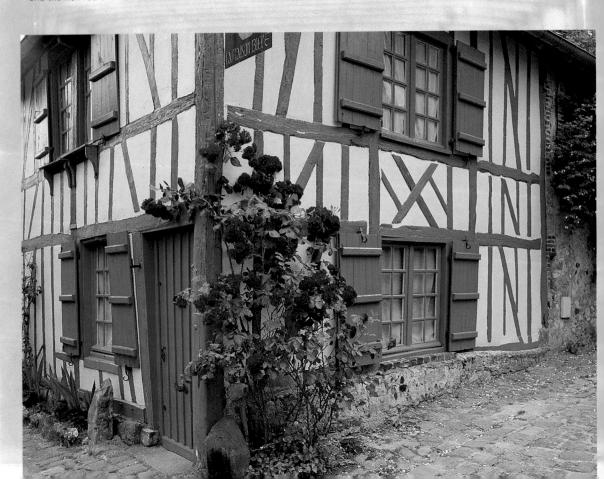

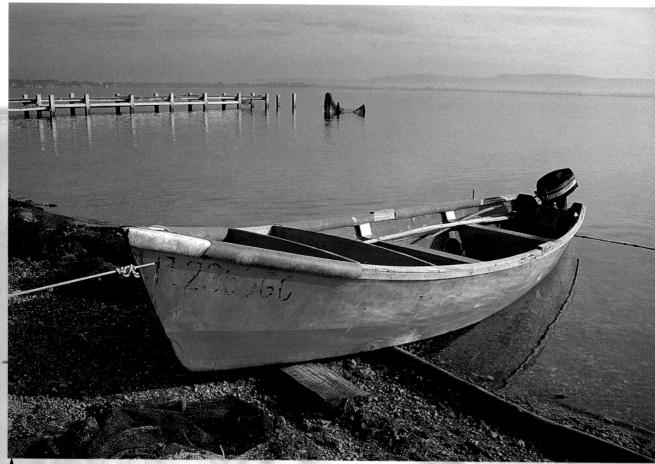

Technical Details

35mm SLR Camera with a 20-35mm zoom lens, 81B warm-up and polarising filters, and Fuji Velvia.

For this picture, taken beside the Etang de Bages in the Languedoc region of France, I was attracted by the calm, mirror-like surface of the water and the overall blueness of the image which was relieved only by the splashes of red on the boat. I used a wideangle lens from a viewpoint close to the boat and framed the image to show as wide an area of the lake as possible.

Rule of Thumb

The golden rule of composition states that the strongest place for the centre of interest in an image is where lines dividing the picture area into thirds horizontally and vertically meet. This will nearly always produce a pleasing effect but should not be followed slavishly. It's best to learn how to identify all of the key elements in an image and to frame a scene in such a way that an overall balance is created between them.

■ Technical Details

Medium-format SLR Camera with a 50mm wide-angle lens, an 81A warm-up filter, and Fuji Velvia.

Magic of Light

Modern films, cameras and accessories make it possible to take photographs when there is little or no light, but just because it's be pleasing. The quality and direction of light is vital to the success

possible does not mean that the outcome will necessarily be pleasing. The quality and direction of light is vital to the success of a photograph and while good lighting can bring a picture to life, so too can a poorly lit scene produce a disappointing result, even when the image is interesting and well composed.

Seeing

I took this photograph on the Brittany coast of France near Morlaix One summer evening. I could see earlier on in the afternoon that there was the likelihood of an Interesting sunset and, while travelling around, had been looking for a possible viewpoint. Water and sunsets can be a powerful combination but some other interest is usually necessary to produce a satisfying photograph.

Thinking

I'd made a note of this small beach with the boats and promontory and when the sun began to go down, headed there to see how it was looking. From Sea level, however, it was a bit disappointing but I had noted a small road leading up away from the beach over a hill and decided to take a look at that.

Technical Details

▼Medium-format SLR Camera with a 55mm wide-angle lens, and Kodak Ektachrome 64.

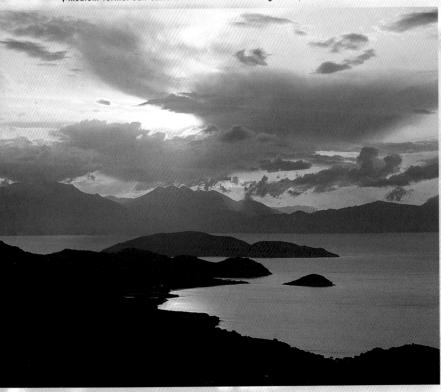

This photograph was taken on the south coast of Crete some time after the sun had set. The much lower contrast and more muted colours have produced a gentler, more romantic image than the previous picture. It's always worth waiting for a while after the sun has set, as this is often when some of the more interesting colour effects are created.

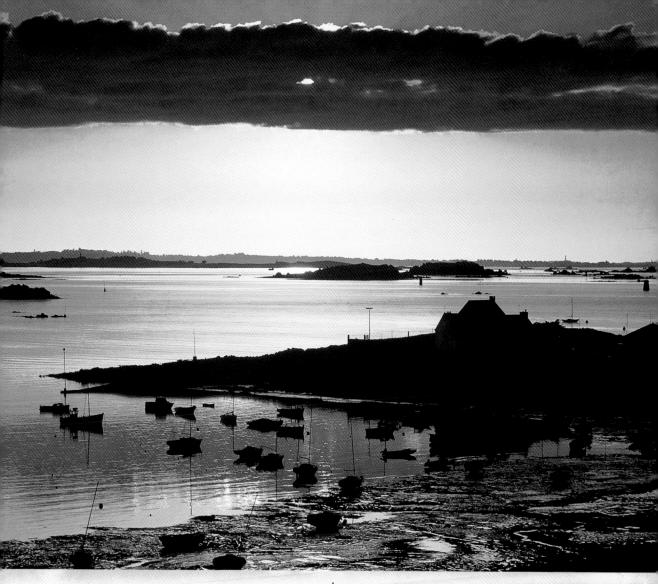

Acting

Although I had not climbed very high the scene took on a very different aspect and I liked the way the sunlight was creating a rich texture on the wet sand and rippled water. My intention was to wait until the sun was on the point of setting but when it momentarily went behind a small cloud bank the time seemed right and I shot this picture. Although I took others just before and after the sunset none of the resulting pictures had this beautiful golden quality.

Technical Details

Medium-format SLR Camera with a 55-110mm zoom lens and Fuji Velvia.

Rule of Thumb

Calculating the exposure for sunsets can be tricky, especially when areas of the sky are very bright and when the sun itself is in the frame. A useful technique is to take a reading from the sky above or to one side of the brightest area, making sure that none of this is included. It is also always wise to bracket your exposure to at least one stop over and one stop under when using transparency film.

Magic of Light

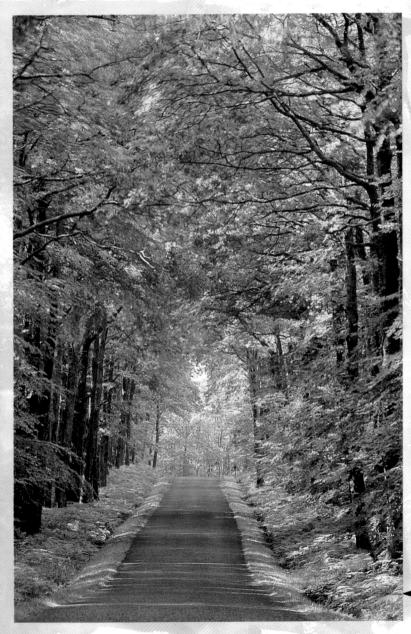

Seeing

This was one of those Opportunist pictures that crop up now and then. I was staying at a small hotel in North Devon, UK, during the winter and woke early. On looking out I was saddened to see a grey, cloudy sky which threatened a rather wet day ahead. Suddenly, however, a shaft of sunlight lit the cliff beside the small bay in a very dramatic way.

Thinking

I could not get to my camera fast enough as I sensed that this gap in the cloud would quickly close. The sun was so low that most of the rocky beach was in shadow and I needed to use a long-focus lens in order to exclude as much of the shadow as possible.

This small road leads through the Forest of Orleans in the Loire region of France. I took this photograph in the early summer when the leaves were still a fresh, delicate green and not yet too dense. This has allowed the sunlight to penetrate the foliage and create an attractive dappled effect as well as making the leaves look translucent. I used a viewpoint in the centre of the road so it led directly away into the centre of the image, and used a long-focus lens to frame a relatively small area of the scene. I used both a polarising filter to increase the colour saturation of the foliage and a warm-up filter to enhance the fresh, green colour of the leaves.

Technical Details

35mm SLR Camera with a 75—300mm zoom lens, 81B warm-up and polarising filters, and Fuji Velvia.

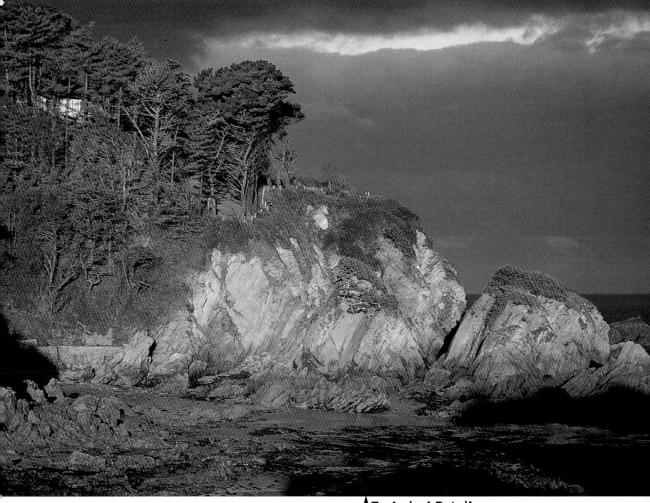

Technical Details

35mm SLR Camera with a 70-210mm zoom lens and Fuji Velvia.

Acting

I had left the tripod in my car and was concerned that I might suffer Camera Shake, so I braced the camera against the edge of the WindoW and framed the image so that all the Sunlit area of the scene was included, as well as the lighter band of cloud above the cliff.

Rule of Thumb

You can learn to judge the effect of light more easily if you make a habit of looking at the shadows in a scene. See if they are dense or weak, large or small or if they have sharp or soft edges. The amount and density of shadow in an image will have a big effect on the contrast of an image. Too much contrast will make a picture harsh and unappealing while too little contrast will make it seem flat and dull.

Magic of Light

Seeing

This almost biblical scene was at the Pushkar camel fair. A small town on the edge of India's province of Rajasthan, and an important place of pilgrimage for Hindus, it hosts this massive country fair each November, where hundreds of thousands of people and animals descend on the town and turn the surrounding sand dunes into a vast, tented suburb.

Thinking

This was just one of three wonderful days when I could hardly bear to put my camera down and encountered photogenic situations at every turn. I was, however, anxious to capture the scene as the day drew to a close, but the sunsets had been non-events, as the haze and smoke from thousands of camp fires made the sun disappear quite early. On this occasion though, there was a pleasing Orange glow in the sky.

Acting

I first tried shooting with a long focal-length lens to frame the silhouetted camels on the brow of the distant hill, with the sun appearing MuCh larger in proportion. The problem was that there were quite a few other keen photographers around, and although they were silhouetted they were nonetheless Very Obvious, especially some standing near the distant group of camels. In the end, I found using a wider-angle lens and including foreground details was a more satisfactory approach.

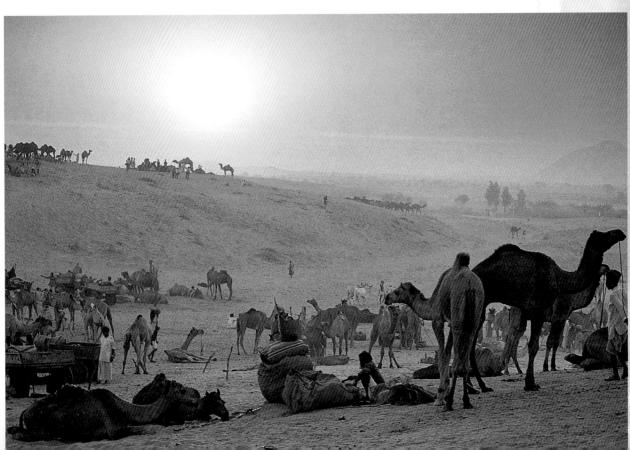

Technical Details

★35mm SLR Camera with a 35-70mm zoom lens and Fuii Velvia.

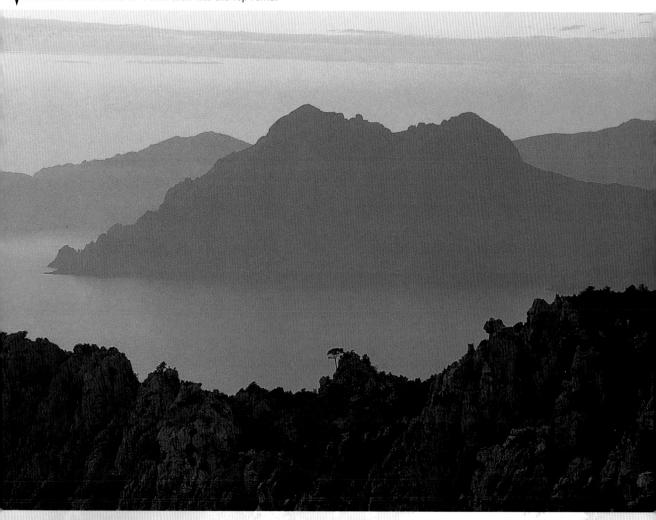

The location for this photograph is the Bay of Porto on the French island of Corsica. This viewpoint is near the village of Piana which is known for the nearby rock formations called Les Calanches. I'd chosen this position in order to photograph the dramatic red rocks at sunset, which are in the foreground of this picture, but waited to see what might develop after the sun had set. I was delighted to find the scene had been transformed into one of soft, pastel pinks and blues, a complete contrast to the scene only a short while earlier.

Rule of Thumb

Judging the density of shadows and the overall contrast of an image can be made easier by viewing it through half-closed eyes or with the lens of an SLR stopped down to a small aperture.

`Technical Details

35mm SLR Camera with a 35-70mm zoom lens and Fuji Provia.

Creating Impact

Many millions of photographs are taken every day but only a very small minority of these have that eye-catching quality which makes them stand out from the crowd. There are a variety of reasons why a particular photograph can have the ability to make people stop and look. It can be an especially dramatic subject, the way in which a scene is composed or lit or, of course, a combination of these things. But the ability to recognise such qualities, and to know how best to harness them, is necessary if you are to shoot pictures which have strong visual impact.

Seeing

This is the castle of Jaen in the Andalucian region of Spain. It's also a parador hotel and I'd stayed there the previous night with the aim of producing an interesting picture.

Thinking

I'd hoped that the early morning light might help to produce the eye-catching quality I hoped for and set my alarm early to be at the VIEWPOINT I'd selected the day before.

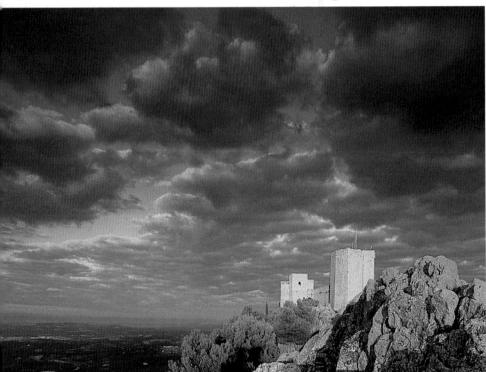

Technical Details 35mm SLR Camera with a 20-35mm zoom lens and Fuji Velvia.

Acting

When the SUN Came
UD I was delighted to
discover that not only was
the castle NICely lit but
the early morning cloud had
a quite dramatic
quality. I framed the
shot in a way which placed
the castle in the corner of
the frame and allowed me to
include a large area of
the sky.

I took this photograph on a beach on the south coast of England late on a summer evening. It had been a hazy day and the lowangled sunlight was glancing along the rippled sand, creating a rich texture and giving the image this curious, but quite natural, purple-tinted quality. I framed the shot so that the brightest highlight fell on the intersection of thirds.

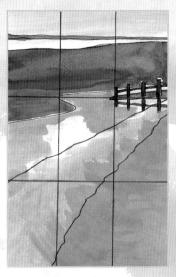

Technical Details

35mm SLR Camera with a 20-35mm zoom lens and Fuji Velvia.

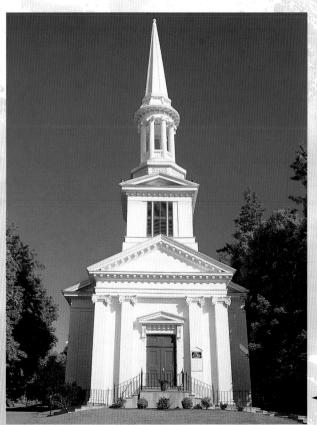

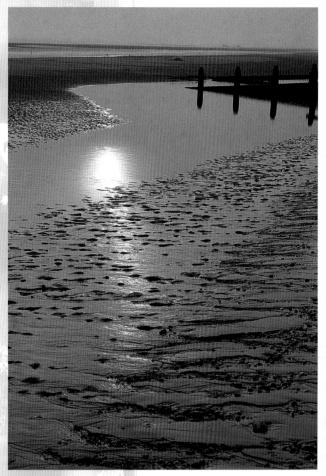

This photograph of a church, seen in a New England village, USA, relies upon two basic qualities for its impact: a simple shape, emphasised by bold lighting, and a restricted range of colours — just white, green and blue. I used a polarising filter to make the sky an even deeper colour and to make the church stand out in even bolder relief.

Technical Details

Medium-format SLR Camera with a 50mm wide-angle lens, 81C warm-up and polarising filters, and Fuji Velvia.

Rule of Thumb

The first thing to consider in terms of creating impact is to ask yourself whether you are standing close enough to your subject. To fill the frame and to exclude extraneous details is one of the most effective ways of creating impact.

Creating Impact

Seeing

This was one of a series of photographs I took while on location in the Algarve region of Portugal. My model had acquired a pretty good tan and I wanted to shoot a picture which exploited this. An image which contains strong colour contrast is always likely to have an eyecatching quality and the sea here was of such a colour that it made a perfect background for her brown skin.

Thinking

I thought the yellow bikini would be a good choice as this, too, made a bold Splash of Colour against both skin and sea. I then asked my model to move into this very angular POSe as the shape it created added another element of impact.

Acting

I used a long-focus lens to frame the image Quite tightly and used a widish aperture to throw the sea Slightly Out of focus and create stronger relief. I used a polarising filter to increase the colour saturation of the water and a warm-up filter to enhance the colour of the model's skin.

Technical Details

35mm SLR Camera with a 75—150mm zoom lens, 81B warmup and polarising filters, and Kodak Ektachrome 64.

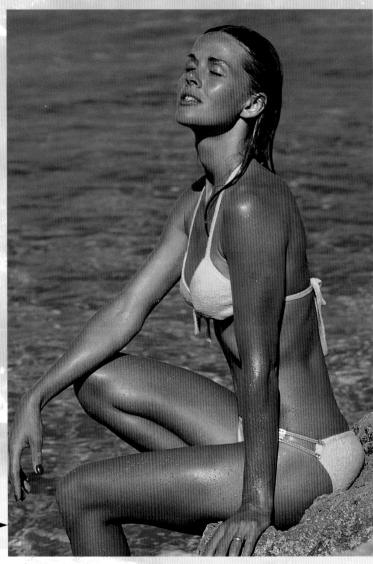

I saw this small boat moored off a heach in the Maldive Islands and was fascinated by the way the boat almost appeared to be suspended. It's partly because of the crystal clear water and also because it's very shallow and the hoat's shadow is clearly visible on the white sand below. I framed the image quite tightly and placed the boat towards the top to allow the inclusion of a large area of the water below. I used a polarising filter to enhance the translucent quality of the sea and to increase its colour saturation.

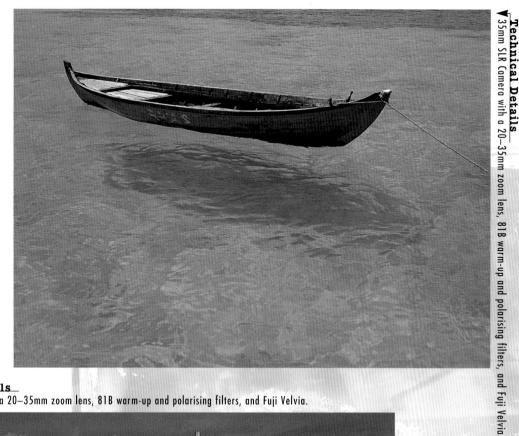

Technical Details

▼35mm SLR Camera with a 20—35mm zoom lens, 81B warm-up and polarising filters, and Fuji Velvia.

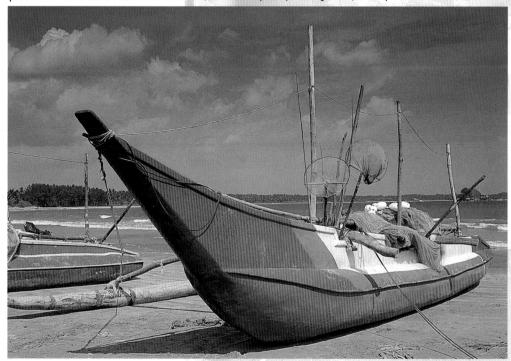

For this shot taken on a beach in Sri Lanka, I used a wide-angle lens and a close viewpoint to accentuate the effect of perspective and give the boat a more dramatic shape. The contrast between the red boat and the blue sky has also added to the picture's impact and I used a polarising filter to further enhance this.

Creating Impact

Technical Details

▼35mm SLR Camera with a 75-300mm zoom lens, an 81B warm-up filter and Fuji Velvia.

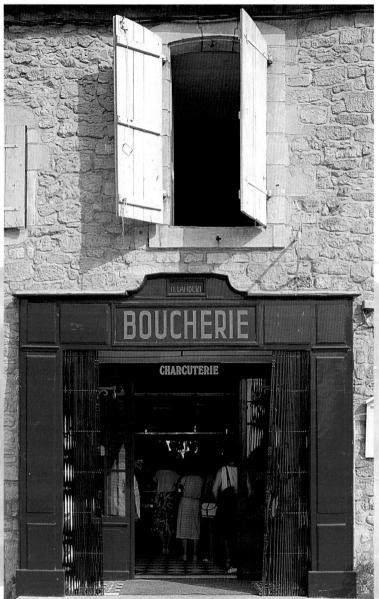

This photograph was taken in the bastide village of Domme in the Dordogne region of France. I was attracted by the red shop front and by the way it contrasted with both the pale stone of the building and the open shutters above. I used a long-focus lens to frame the image tightly from a fairly distant viewpoint. This has enabled me to tilt the camera upwards to include the window without making the vertical lines appear to converge very noticeably.

Rule of Thumb

Elements within an image which contrast with each other usually tend to add impact to an image. A contrast between a light subject and a dark background, for instance, between two dominant colours or between the shapes of objects in a scene, can all help to give an image that eyecatching quality which makes it stand out from the rest.

Technical Details

▼ Medium-format SLR Camera with a 55—110mm wide-anale lens and Fuii Velvia.

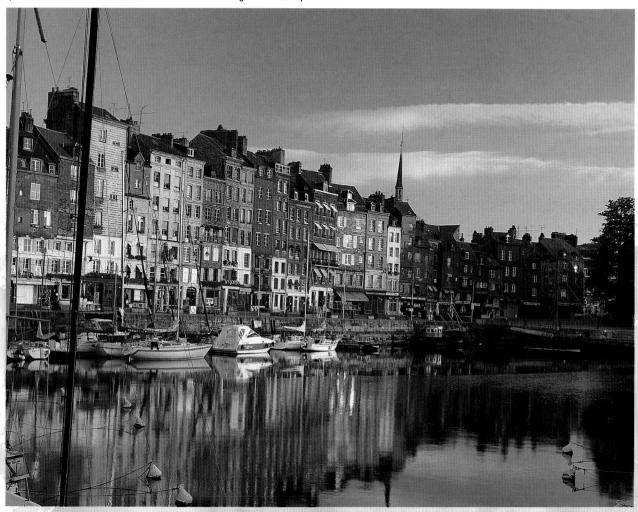

Seeing

The old town of Honfleur in the Normandy region of France is one of MY favourite places and I have been there a good few times. On this occasion I had got up really early in order to photograph the country market held there each Saturday in the picturesque cobbled square. I was too early for the market, however, and wandered down to the quayside to see the SUN just coming up.

Thinking

The effect of the low-angled orange-tinged sunlight was very striking and I set up my camera immediately at this VIEWPOINT, which showed the houses reflected in the water and gave me a pleasing angle on the row of houses.

Acting

My first thought was to frame the image MORE tightly concentrating on the sunlit area of the scene. But on consideration I decided that by widening my angle of view and including some of the bluer shadow tones it would increase the impact of the Warmly-lit buildings. This has also allowed me to include more of the reflections.

Using Colour Creatively

The vast majority of photographs these days are taken on colour film but only a small minority of these stand out as being good colour

photographs. It's important to view the colour content of a subject or scene with the same amount of care and discrimination as you would when deciding how to decorate a room, or when choosing clothes, if you are to produce really satisfying and eye-catching colour photographs.

Seeing

was travelling in the late autumn through the countryside near Chambery in the French Alps when I Came across this stunning tree with the most VIVID red leaves. The sky was slightly hazy and consequently the sunlight was not quite as Sharp and clear as I would have liked.

Thinking

I decided that it would be most striking if I could find a viewpoint where it would be contrasted against the reasonably blue sky or the green foliage surrounding it.

This attractive waterfall is near the village of Baumes les Messieurs in the Jura region of France, I took this picture in the spring when the foliage was very fresh and light in colour. It was this colour which appealed to me about the scene and I framed the image so that areen became the dominant colour of the image. I used a small aperture to enable the use of a slow shutter speed which has recorded the moving water as a soft, smoke-like blur.

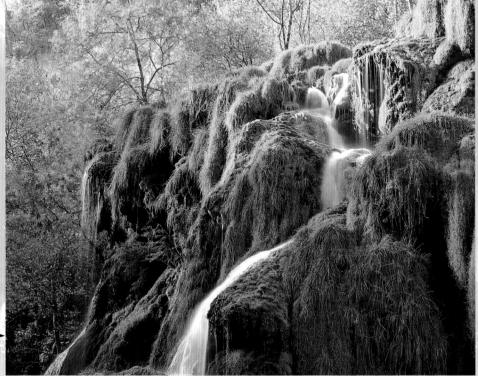

Technical Details

Medium-format SLR Camera with a 150mm lens, 81C warm-up and polarising filters, and Fuji Velvia.

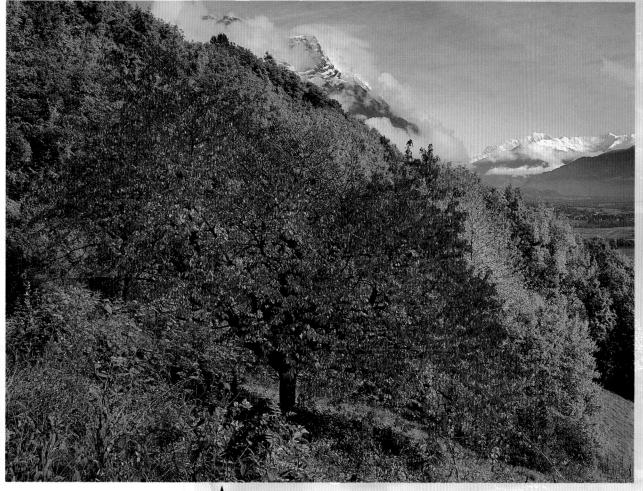

**Medium-format SLR Camera with a 50mm wide-angle lens, 81C warm-up, neutral-graduated and polarising filters, and Fuji Velvia.

Acting

I finally found this spot where a slightly lower viewpoint placed the tree against the bluest part of the sky, and also allowed me to frame it in such a way that it was also bordered by green. I liked the way the tree created a diagonal red band across the frame. I used a polarising filter to increase the colour saturation, a neutral-graduated filter to make the blue sky as dark as possible and a Warm-up filter to further enhance the red.

Rule of Thumb

Colour contrast is one of the most effective ways of creating impact in a colour photograph, especially when the image is restricted to two dominant colours which are far apart in the spectrum – for example, blue contrasted with yellow or red with blue. The effect can be quite striking when a small area of one colour is set against a background of the opposite hue.

Using Colour Creatively

Seeing

Although blue is a COMMONPLACE colour in nature, I always find it very Interesting in other situations and when I spotted these blue rain covers on the moored gondolas during a trip to Venice, I felt there was the possibility of an Interesting picture.

Thinking

The background of the lagoon water also had a bluish quality but at the same time showed up the elegant shapes of the crafts very effectively. I also like the poles which created a contrasting shape and a patterned effect within the scene.

Technical Details

▼35mm SLR Camera with a 100-300mm zoom lens and Fuji Velvia.

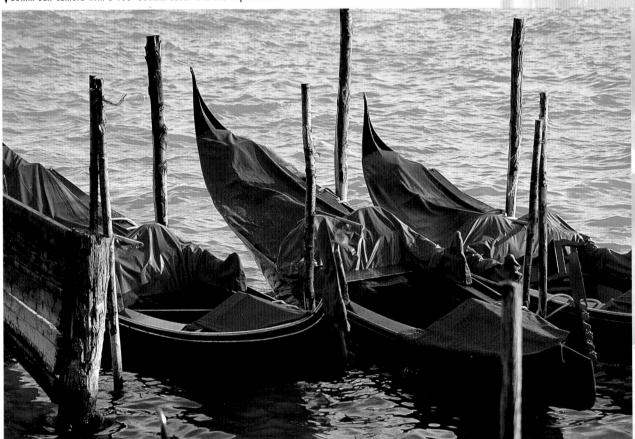

Acting

There was a large number of gondolas tied up at this spot and it was necessary to find a VIEWPOINT from which I could separate just a few from the crowd. From this spot I was able to frame just three crafts at the end of the group, using a long-focus Iens, in a way which emphasised their shape and which also gave me a pleasingly balanced arrangement of poles.

I spotted this display of vegetables while wandering around a country market in Sri Lanka and was struck by the juxtaposition of green and purple. I found a viewpoint which allowed me to include some of the aubergines in the foreground and framed the shot to include the other pile in the background.

Technical Details

35mm SLR Camera with a 35—70mm zoom lens, an 81A warm-up filter and Fuji Provia.

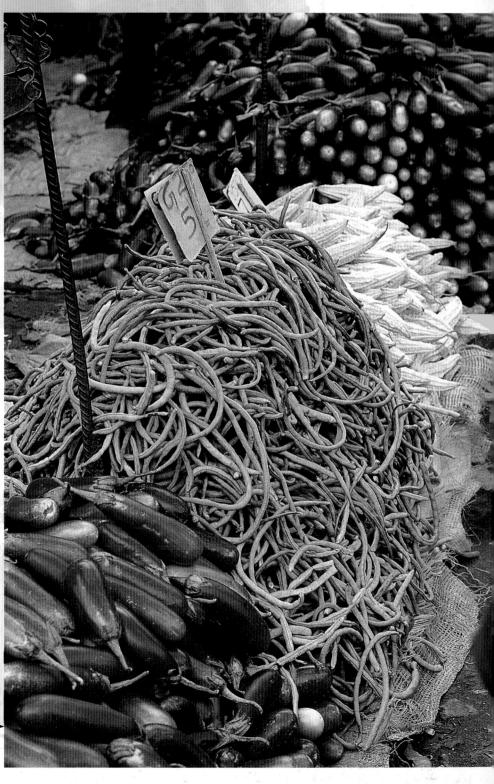

4

Vacation photography can involve tackling a wide range of subjects, from action pictures on the beach to landscapes, buildings, close-

ups and people. Whether you are an enthusiast willing to carry a comprehensive outfit on your holiday or simply want to get the best results possible from a more simple camera, having the right tools for the job can make a big difference, both to the ease of working and to the results achieved. Choosing the right equipment for your particular interests and understanding how to use it to its full advantage is the first step.

Choosing a Camera

Formats

Image size is the most basic consideration. The image area of a 35mm camera is approximately 24x36mm but with roll film it can be from 45x60mm up to 60x90mm according to camera choice. The degree of enlargement needed to provide, say, an A4 reproduction is much less for a roll film format than for 35mm and gives a potentially higher image quality.

For most photographers the choice is between 35mm, APS and 120 roll film cameras. APS offers a slightly smaller format than 35mm and for images larger than 6x9cm it is necessary to use a view camera of 5x4in or 10x8in format.

Pros & Cons

APS cameras have a more limited choice of film types and accessories and are designed primarily for the use of colour negative film. 35mm SLR cameras have the widest range of film types and accessories and provide the best compromise between image quality, size, weight and cost of equipment. Both accessories and film costs are significantly more expensive with roll film cameras, and the range of lenses and accessories more limited than with 35mm equipment.

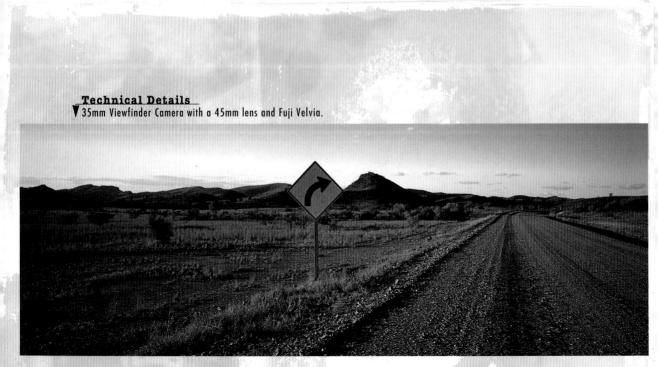

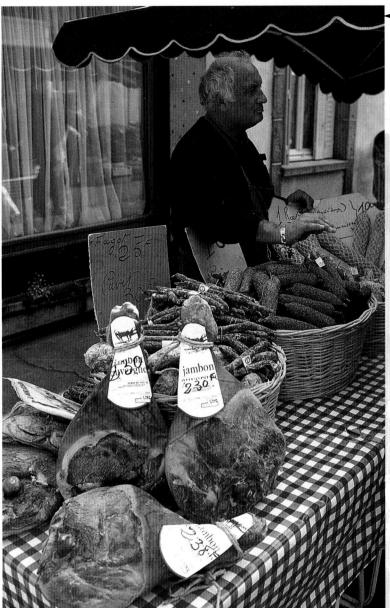

Technical Details

35mm SLR Camera with a 24—85mm zoom lens, an 81A warm-up filter and Kodak Ektachrome 100 SW.

I used my 35mm SLR for this picture taken in a French market but it is the type of subject which can be handled equally well with a 35mm viewfinder or compact camera.

Waterproof and Underwater Cameras

It's possible to buy cameras which can be used underwater to a considerable depth, for serious Sub-aqua photography, or simpler models which are waterproof and also capable of being taken a few metres under the surface. These can be an ideal choice for those who wish to use their camera to photograph water Sports or for a situation such as a beach, without fear of water or Sand damage.

Digital Cameras

These are now a feasible alternative to film cameras, as one or two million pixel resolution can produce ink-jet prints up to 7x5in, comparable in quality to those from a photolab. Digital cameras have an advantage in that the results can be seen immediately and assessed, allowing the option to reject bad results and re-shoot straight away. The disadvantage is that the storage capacity of images at high resolution is quite limited.

This shot of The Australian Outback was taken on a special panoramic camera. Many more simple cameras have an optional panoramic setting, the APS system for instance, which can help to produce a more pleasing composition with some subjects.

Camera Types

There are two basic choices between Roll Film, 35mm and er or Rangefinder Camera and

APS Cameras; the Viewfinder or Rangefinder Camera and the Single Lens Reflex, or SLR.

Pros & Cons

An SLR allows you to view through the taking lens and to see the actual image which will be recorded on the film, but the viewfinder camera uses a separate optical system. This can be a major disadvantage with close-up photography in particular, as an optical viewfinder becomes increasingly inaccurate as the camera is moved closer to the subject.

In addition, the whole image appears In focus when seen through a viewfinder camera but the effect of focusing can be seen on the screen of an SLR, making it possible to more accurately judge the depth of field. It is also much easier to judge and control the effect of filters, such as polarisers and neutral graduates when using an SLR.

Generally, facilities like autofocus and exposure control are more accurate and convenient with SLR cameras and you can see the effect of filters and attachments. SLR cameras have a much wider range of accessories and lenses available to them and are more suited to subjects like wild life when very long-focus lenses are needed. Viewfinder cameras, such as the Leica or Mamiya 7, tend to be lighter and quieter than their equivalent SLRs, but they are not ideally suited to close-up photography because of the limitations of the viewing system.

For this close-up of a limpet shell I used a 35mm SLR with a macro lens.

Technical Details

▼Medium-format SLR Camera with a 55—110mm zoom lens, 81C warm-up and polarising filters, and Fuji Velvia.

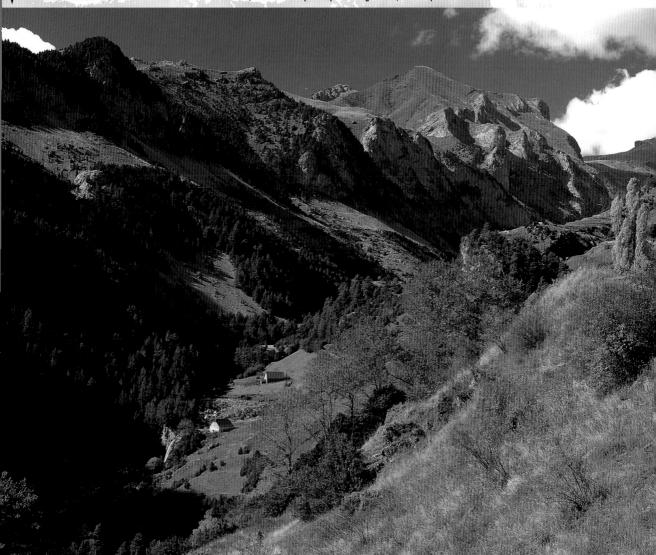

I used my medium-format camera for this landscape, photographed in the Spanish Pyrenees near the town of Bielsa. The additional degree of sharpness and tonal quality of the larger format over 35mm can be an advantage with this type of subject, especially when the image is reproduced very large.

Technical Details

35mm SLR Camera with a 90mm macro lens, and Kodak Ektachrome 100 SW.

Choosing Lenses

A standard lens is one which creates a field of view of about 45° and has a focal length equivalent to the diagonal measurement of the film format i.e. 50mm, with a 35mm camera and 80mm with a 6x6cm camera.

Lenses with a shorter focal length create a WIGEr field of view and those with a longer focal length produce a narrower field of view. Zoom lenses provide a wide range of focal lengths within a single optic, taking up less space and offering more convenience than having several fixed lenses.

Pros & Cons

Many ordinary zooms have a maximum aperture of f5.6 or smaller. This can be quite restricting when fast shutter speeds are needed in low light levels and a fixed focal-length lens with a Wider maximum aperture of f2.8 or f4 can sometimes be a better choice. Zoom lenses

are available for most 35mm SLR cameras over a wide range of focal lengths but it's important to appreciate that the image quality will be lower with lenses which are designed to cover more than about a three to one ratio, i.e. 28–85mm or 70–210mm.

Special Lenses

A lens of more than 300mm will seldom be necessary for the majority of photographic subjects, but one between 400mm and 600mm is often necessary to obtain close-up images of subjects, such as sports, wild animals and birds.

Extenders can allow you to increase the focal length of an existing lens; a x1.4 extender will make a 200mm lens into 300mm and a x2 extender to 400mm. There will be some loss of sharpness with all but the most expensive optics and a reduction in maximum aperture of one and two stops respectively.

Using a wide-angle lens for this picture of a holiday villa in Spain has enabled me to include the bougainvillea in the close foreground as well as all of the house and the tree on the left-hand side. This has helped to give the image a threedimensional quality, as well as showing the villa in the context of its setting. I used a small aperture to obtain maximum depth of field.

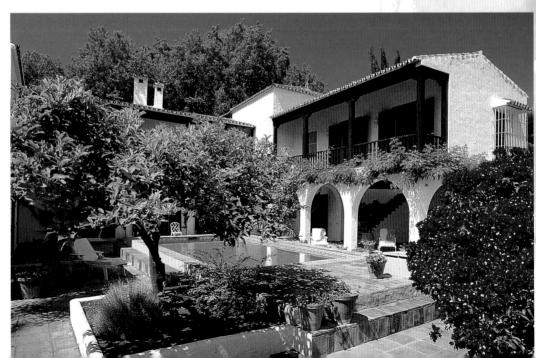

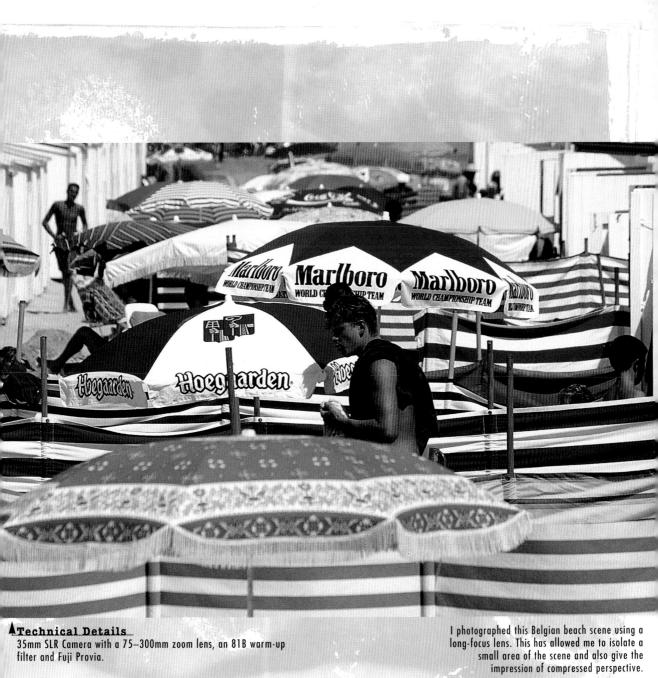

Technical Details

35mm SLR Camera with a 20mm wide-angle lens, 81C warm-up and polarising filters, and Fuji Velvia.

Camera Accessories

There are a wide range of accessories which can be used to control the image and increase the camera's canability

Extension tubes bellows units and dioptre lenses will all allow the lens to be focused at a closer distance than it's designed for

A selection of filters will help to extend the degree of control over the colour quality of an image and a Square filter system. such as Cokin or HiTech, is by far the most convenient and practical option. These allow the same filters to be used with all VOUR lenses regardless of the size of the lens mounts, as each can be fitted with an adapter upon which the filter-holder itself can be easily slipped on and off.

A polarising filter is extremely useful for reducing the brightness of reflections in non-metallic surfaces, such as foliage, and will also make a blue sky record as a richer blue. creating greater relief with white clouds

Polarisers are available in either linear or circular form. The former can interfere with some auto-focusing and exposure systems. Your camera's instruction book should tell you, but if in doubt use a CIRCULAR polariser.

Technical Details

35mm SLR Camera with a 24-85mm zoom lens, an extension tube and Fuji Velvia.

Technique
A Soft-focus filter can be effective in some circumstances to reduce contrast and colour saturation and help create a more romantic mood for subjects such as portraits and landscapes.

Technique

A tripod should be considered obligatory whenever it is possible to use one as it enables you to aim, frame and focus the camera on your subject with the knowledge that it will remain accurately positioned. This allows you to concentrate more on matters like composition and lighting.

A photograph like this close-up shot of a detail of the cathedral door in Cordoba, Spain, needed an extension tube or bellows unit to enable a normal lens to focus at a close enough distance.

Rule of Thumb

It's best to buy the most substantial tripod you feel able to carry comfortably, as a very lightweight one can be of limited usefulness. A shakefree means of firing the camera, such as a cable release or a remote trigger, is advisable when using a tripodmounted camera.

This diagram shows an extension tube fitted between the camera body and lens.

Rule of Thumb

Perhaps one of the most important accessories which can significantly improve your photography is a tripod, as it can greatly improve image sharpness. The effects of camera shake are much more noticeable when the subject is close to the camera and small apertures are often needed to create sufficient depth of field; a tripod allows slower shutter speeds to be used without risk. A tripod is also extremely useful when you wish to include yourself in a picture using the camera's delay setting.

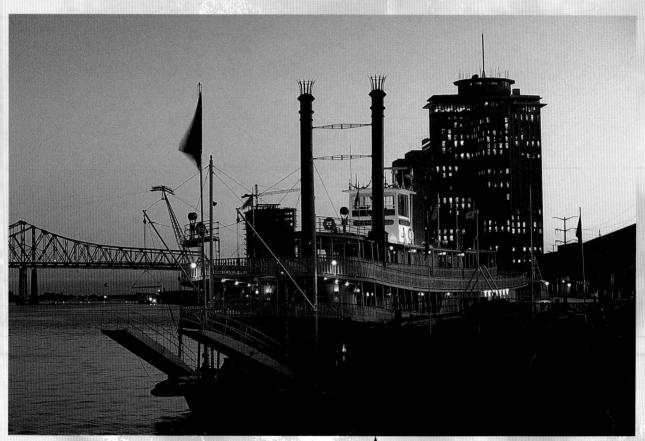

Technique A Polaroid back can be bought to fit many

A Polaroid back can be bought to fit many professional roll film and 35mm cameras such as the Canon EOS1N and the Mamiya 645. These can be extremely useful when using flash lighting as the exact effect of the Set-up can be seen before the image is exposed onto normal film.

Technical Details

35mm SLR Camera with a 75-300mm zoom lens and Fuji Velvia.

I took this photograph of New Orleans, USA, some time after sunset, by which time it was getting quite dark. I needed an exposure of around one second which made the use of a tripod essential.

Apertures & Shutter Speeds

The aperture is the device which controls the brightness of the image falling upon the film and is indicated by f stop numbers: f2, f2.8, f4, f5.6, f8, f11, f16, f22 and f32. Each Step down, from f2.8 to f4 for example, reduces the amount of light reaching the film by 50% and each step up, from f8 to f5.6 for instance,

doubles the brightness of the image.
The shutter speed settings control the length of times for which the image is allowed to play on the film and, in conjunction with the aperture, control the exposure and quality of the image.

Technique

The choice of shutter speed determines the degree of sharpness with which a moving subject will be recorded. With a fast-moving subject, like an animal running or a bird flying for instance, a shutter speed of 1/1000 sec or less will be needed to obtain a Sharp image.

Technique

Choice of aperture also influences the depth of field, which is the distance in front and beyond the point at which the lens is focused. At WIDE apertures, like f2.8, the depth of field is quite limited making closer and more

distant details appear distinctly Out of focus. The effect becomes more pronounced as the focal length of the lens increases and as the focusing distance decreases; so with, say, a 200mm lens focused at one metre and an aperture of f2.8 the range of Sharp focus will extend only a very short distance in front and behind the subject. The depth of field increases when a Smaller aperture is used and when using a short focal length, or wide-angle lens. A camera with a depth of field preview button will allow you to judge the depth of field in the viewfinder.

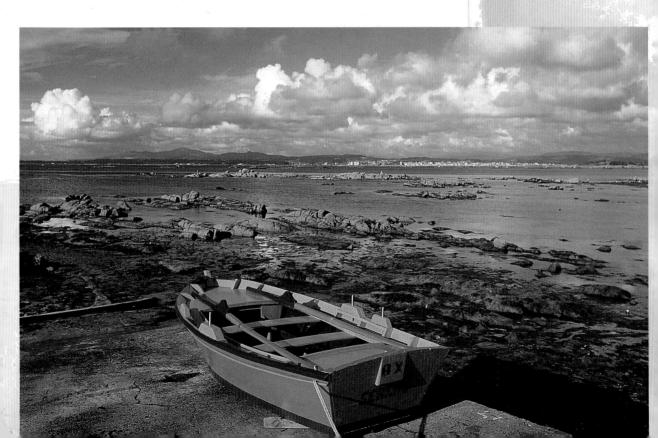

Technical Details √35mm SLR Camera with a 35—70mm zoom lens, 81C warm-up and polarising filters, and Fuji Velvia.

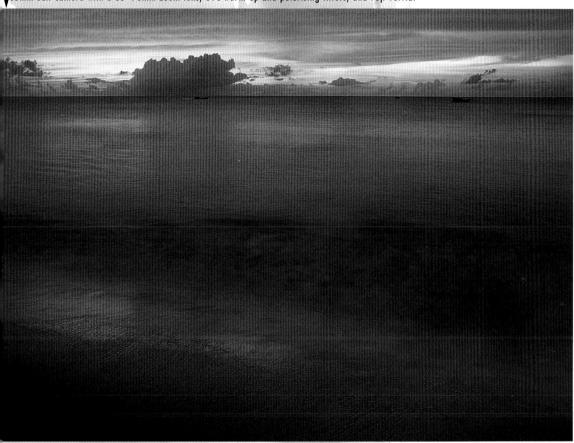

I used a shutter speed of about two seconds to record the moving water as a soft smokelike blur in this photograph, taken in Tobago, some time after the sun had gone down. A tripod was essential to ensure that the static elements of the image remained sharp.

For this scene, photographed in the Galicia region of Spain, I set a small aperture to ensure that the image was as sharp as possible from the closest to the furthest details.

Technical Details

35mm SLR Camera with a 20—35mm zoom lens, 81C warm-up and polarising filters, and Fuji Velvia.

Rule of Thumb

The choice of shutter speed can also affect the image sharpness of a static subject when the camera is hand-held as even slight camera shake can easily cause the image to be blurred. The effect is more pronounced with long-focus lenses and when shooting close-ups. The safest minimum shutter speed should be considered as reciprocal of the focal length of the lens being used; 1/200 sec with a 200mm lens, for instance.

Understanding Exposure

Modern cameras with automatic exposure systems have made some aspects of achieving good quality images much easier, but no system is infallible and an understanding of how exposure meters work will help to ensure a higher success rate.

An exposure meter, whether it's a built-in TTL meter or a separate hand meter works on the principle that the subject it is aimed at is a mid-tone, known as an 18% grey. In practice, of course, the subject is invariably a mixture of tones and colours but the assumption is still that, if mixed together, like so many pots of different-coloured paints, the resulting blend would still be the same 18% grey tone.

With most subjects the reading taken from the whole of the SUDJECT will produce a satisfactory exposure. But if there are aspects of a subject which are abnormal – when it contains large areas of VETY light or dark tones, for example – the reading needs to be modified.

An exposure reading from a snow scene for instance, would, if uncorrected, record the white snow as grey on film. In the same way, a reading taken from a very dark subject would result in the image being too light.

The exposure needs to be decreased when the subject is essentially dark in tone or when there are large areas of shadow close to the camera. With abnormal subjects it is often possible to take a close-up or spot-reading from an area which is of normal, average tone.

Technical Details

★35mm SLR Camera with a 24-85mm zoom lens, 81C warm-up and polarising filters, and Fuji Velvia.

These pictures show the effect of bracketing exposures. The central image received the exposure indicated by the meter while the two darker frames had a third and two thirds of a stop less and the two lighter frames had a third and two thirds of a stop more.

Technique

Many cameras allow you to take a spot-reading from a small area of a scene as well as an average reading, and this can be useful for calculating the exposure with subjects of an abnormal tonal range or of high contrast. Switching between the average and spot-reading modes is also a good way of checking if you are concerned about a potential exposure error. If there is a difference of more than about half a stop, when using transparency film, you need to consider the scene more carefully to decide if a degree of **EXPOSURE** compensation is required.

Rule of Thumb

The most common situations in which the exposure taken from a normal average reading needs to be increased are when shooting into the light, when there are large areas of white or very light tones in the scene, when there is a large area of bright sky in the frame and when bright light sources are included in the image, such as a street scene at night.

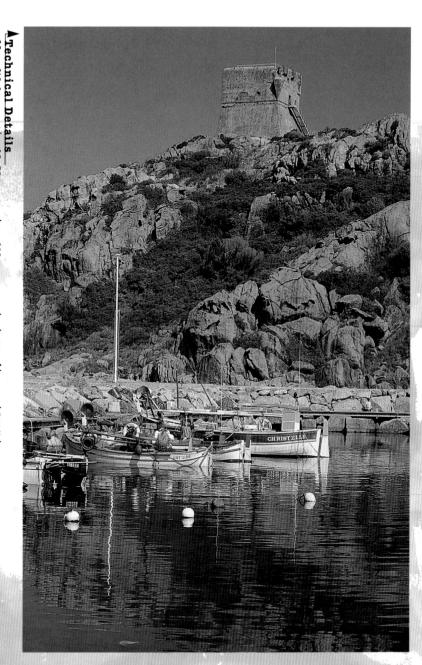

This photograph is of the small harbour of the village of Porto on the French island of Corsica. Being a subject of normal tonal range and contrast, the camera's exposure meter gave me an accurate reading which needed no compensation.

Understanding Exposure

With negative films there is a latitude of one stop or more each way and small variations in exposure errors will not

be important, but with transparency film even a slight variation will make a significant difference to both the image quality and the colour saturation, where possible. It's best to bracket exposures giving a third or half stop more or less than indicated, even with normal subjects.

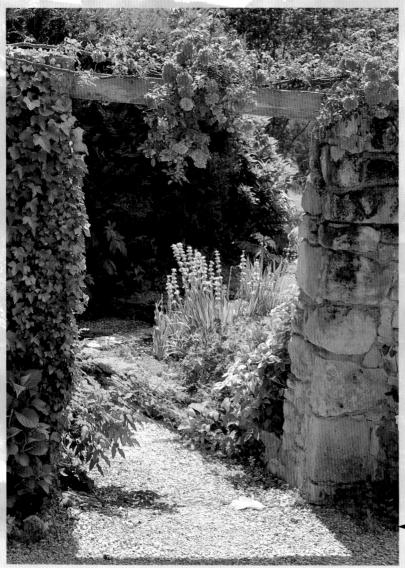

Technique

Clip testing is an effective way of overcoming this problem. For this technique you need to establish your exposure and shoot a complete roll at the same setting, assuming the lighting conditions remain the same. You need to allow two frames at the end of the roll, in the case of roll film, or shoot three frames at the beginning of a 35mm film, which you must ask the processing laboratory to CUT Off and process normally. The exposure can then be judged and the processing time of the remainder of the film adjusted to make the balance of the transparencies lighter or darker if necessary. Increasing the effective speed of the film, known as pushing, and making the transparency lighter, is more effective than reducing the film speed, known as pulling, to make the image darker. For this reason it is best to set your exposure slightly less than calculated if in any doubt.

For this photograph of a garden I gave two-thirds of a stop more exposure than was indicated to compensate for the back-lighting as the exposure meter would have been influenced by the bright highlights and would have indicated less exposure than was really needed. This would have resulted in the shadow tones being too dark and lacking in detail.

Technical Details

Medium-format SLR Camera with a 55—110mm zoom lens, 81C warm-up and polarising filters, and Fuji Velvia.

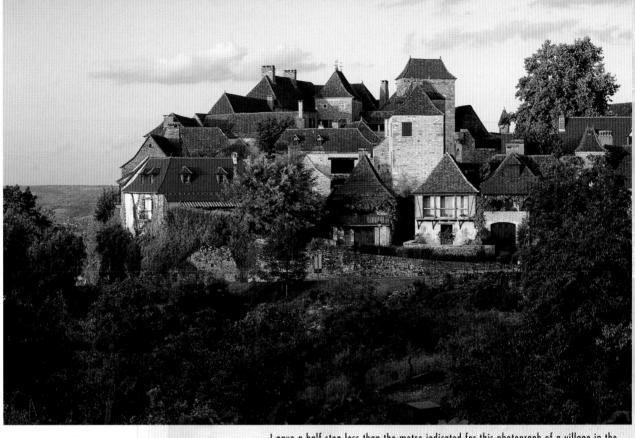

I gave a half stop less than the metre indicated for this photograph of a village in the Dordogne region of France, as the exposure meter would have been influenced by the dark, shadowed foreground and indicated more exposure than was necessary. This would have recorded the sunlit houses as too light a tone.

Technique

Exposure compensation can also be used to alter the quality and effect of an image, especially with transparency film. When a lighter or darker image is required this can be adjusted at the printing stage when shooting on negative film, but with transparency film it must be done at the time the film is exposed.

Rule of Thumb

Although bracketing is effective when dealing with a completely static subject like a landscape or still life it's not always the best solution when taking photographs in situations where the subject is moving, such as when photographing people or animals. Even a slight change in the expression or posture can make one frame very much better than the next and in a bracket this might not be the best exposure.

Choosing Film

There is a huge variety of film types and speeds from which to choose and although, to a degree, it is dependent on personal taste,

there are some basic considerations to be made. Unless you wish to achieve special effects through the use of film grain it is generally best to choose a slow, fine-grained film for most colour photography if the subject and liahting conditions permit.

Technical

The choice between colour negative film and transparency film depends partly upon the intended use of the photographs. For book and magazine reproduction, transparency film is universally preferred and transparencies are also demanded by most photo libraries. Transparency film is also necessary for slide presentations. For personal use, and for when colour prints are the main requirement, colour negative film can be a better choice since it has greater exposure latitude and is capable of producing high-quality prints at a lower cost.

__Technical Details ▼35mm SLR Camera with a 17-35mm zoom lens and Kodak Ektachrome 100 SW.

For this photograph of the cellars of Chateau Lafite Rothschild in France I deliberately used daylight-type film, even though the cellars were lit by artificial lighting; I felt the resulting orange cast would enhance the picture's atmosphere.

Technical

Colour negative film is also the best choice if you are shooting in mixed lighting, or under unknown conditions, such as fluorescent light, as it is more tolerant of colour casts and can be Corrected at the printing stage.

Technical

Many films are now produced to suit different subjects such as portraits and landscapes. A warm, strongly saturated film such as Fuji Velvia is ideal for landscapes for example, but does not produce very flattering skin tones.

Rule of Thumb

With all film types, their speed determines the basic image quality. A slow film of ISO 50, for instance, has finer grain and produces a significantly sharper image than a fast film of, say, ISO 800. The accuracy and saturation of the colours will also be superior when using films with a lower ISO rating.

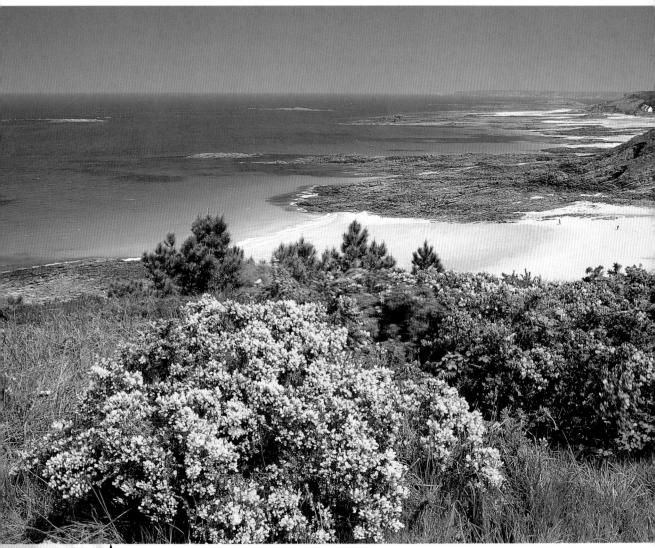

Technical Details

Medium-format SLR Camera with a 50mm wide-angle lens, 81C warm-up and polarising filters, and Fuji Velvia.

I used Fuji Velvia for this shot, taken on the Brittany coast of France, in order to maximise the rich colours of the yellow gorse and blue sea.

LAIRD LIBRARY

Glasgow College of [

60 North I

Rule of Thumb

When shooting on colour transparency film it is necessary to ensure you are using artificial-light film for indoor situations with tungsten lighting, as otherwise the pictures will have a pronounced orange cast. Conversely, this film will produce a strong blue cast if used in daylight.

Using Filters

Even in the best conditions, filters are often necessary, especially when shooting on transparency film. It's important to appreciate that colour transparency film is manufactured to give correct

colour balance only in conditions when the light source is of a specific colour temperature. Daylight colour film is balanced to give accurate colours at around 5,600 degrees Kelvin but daylight can vary from only about 3,500 degrees K close to sundown, to nearly 20,000 degrees K in open shade when there is a blue sky.

The effect of an imbalance between the colour temperature of the light source and that for which the film is balanced can be very noticeable. The blue tint, for example, when shooting in open shade can be quite marked and in these situations a Warm-up filter, such as an 81A or B is needed. In late afternoon the sunlight can be excessively Warm for some subjects and then a blue-tinted filter such as an 82A or B is needed.

A polarising filter can be very useful for increasing the colour saturation of details such as foliage and for making the sky or sea a richer colour. It is equally effective when used with Colour print film, whereas the qualities created by colour balancing filters can easily be achieved when making colour prints from negatives.

A polariser can also help to subdue excessively bright highlights when shooting into the light, like the sparkle on rippled water. Polarisers need between one and a half and two stops extra exposure but this will automatically be allowed for when using TTL metering.

I used a polarising filter for this seascape, taken in the Galicia region of Spain, to increase the colour saturation of the sky, make the clouds stand out in stronger relief and give the water a more translucent quality.

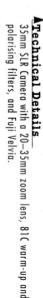

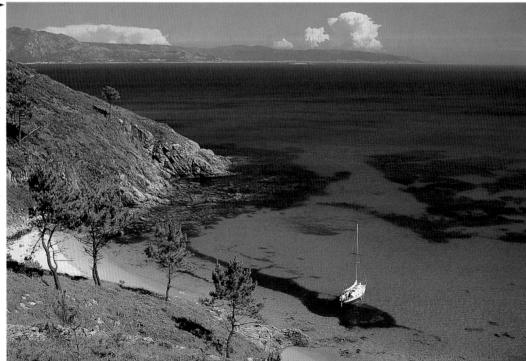

Neutral-graduated filters are a very effective means of making the sky darker and revealing richer tones and colours. They can also reduce the COntrast between a bright sky and a darker foreground giving improved tones and colours in both. Coloured versions of these filters can also be bought but they do need to be used with discretion as the results can very easily look unnatural, and, unless used in the right circumstances, will tend to produce rather Crude and obvious images.

35mm SLR Camera with a 35-70mm zoom lens, a neutralgraduated filter and Fuji Velvia.

I used a neutral-graduated filter for this stormy seascape photographed on the north coast of Spain. It has prevented the sky from over-exposing, revealing richer tones and colour.

Travelling with a Camera

It's good to remember that, unless this is a holiday designed specifically to take photographs, it is wise to restrict the amount of equipment you take. Lugging a heavy camera bag around every day will very soon become a chore and the temptation to leave it behind "just today" will grow and grow.

I have what I call my minimalist kit which consists of a camera body, a set of filters, two zoom lenses and a CONVERTER which gives me a choice of focal lengths ranging from 24mm to 280mm and there are very few occasions when I really feel I need something else. However, I do carry a lightweight tripod which more than compensates for the effort by allowing me to shoot pictures in low light, such as night scenes, which would otherwise be impossible. A flash gun is useful on occasions when the light level is too low for available light photography and it can also be used for fill-in flash when shooting in contrasty sunlight, for example.

Customs

You can overcome many of the potential problems which might be experienced when passing through customs control if you make a duplicated list of all your equipment, together with serial numbers and keep it in your passport. This will also be invaluable if you have to make an Insurance claim.

Insurance

It is best not to rely upon all-inclusive holiday insurance if you are carrying valuable cameras and lenses as they may well not be adequately covered. It is preferable to take out a Specialist camera insurance and make sure it covers all the countries to which you are travelling.

I used a tripod for this interior photograph of an antique shop in New England, USA, as a slow shutter speed was needed to record the ambient light.

▲ **Technical Details**35mm SLR Camera with a 20—35mm zoom lens and Fuji Velvia

Rule of Thumb

Make it a rule to never take a new and untried piece of camera kit away on a vacation. It is so much better to be really familiar with the equipment you are using; it will greatly reduce the risk of disappointments due to equipment failure if you stick to those which are tried and tested.

Technique

Carrying a quantity of film when travelling by air can be a problem these days as the SCANNING EQUIPMENT used for luggage placed in the aircraft's hold can SERIOUSLY damage film by fogging. It's now necessary to carry all your film as hand luggage. Unless it is very fast, in excess of ISO 1000, it will not come to any harm with the modern X-ray machines used in most international airports, but you can always try asking for a hand search if you are concerned.

I used a small flash gun to provide fill-in flash for this backlit shot of a Koala bear in order to enhance the texture of its fur

Technical Details

35mm SLR Camera with a 70—200mm zoom lens, an 81A warm-up filter and Fuji Velvia.

Rule of Thumb

It's wise to be well stocked with batteries as some types are difficult to find, especially if you are travelling off the beaten track. Also bear in mind that battery life is reduced in extremes of temperature.

Finishing & Presentation

Storing your Photographs

Card mounts are the most suitable way of storing and presenting colour transparencies. They can be printed with your name and address together with caption information using labels. Added protection can be given by the use of individual clear plastic sleeves which slip over the mount.

Technique

Even the finest print will be improved by good presentation, and mounting it flat onto a heavy-weight card is the first stage using dry-mounting tissue or spray adhesive. The addition of bevel cutout mount on top will give it a very professional finish. You can cut these yourself to size using a craft knife – or there are special tools available – but they can also be bought ready-made in the most popular sizes from art stores. A group of prints finished in this way and nicely framed can look great on the walls of a home or office.

Rule of Thumb

Holiday experiences and accounts can be of considerable interest to a variety of magazines and if you have a collection of photographs on a particular destination, or of a certain hotel, restaurant or holiday activity, and can write, say, 1000 words to accompany them you will have an excellent chance of placing them with the right type of publication.

Technique

For purely personal use, many photographers use flip-over albums as a means of showing their prints. This method is, at best, simply a convenient way of storing prints and does nothing to enhance their presentation. It can be far more pleasing and effective to show a collection of images as a series of prints mounted on the pages of an album, choosing one large enough to allow six or more photos to be seen together on a spread.

There are a number of ways of selling your work and finding a potential outlet for it in print. Good colour photographs of all manner of subjects, ranging from landscapes to plants and gardens, architecture and people are in constant demand by publishers of magazines and there is a ready market for most topics if the photographs are well executed.

Rule of Thumb

The simplest way of storing mounted transparencies is in viewpacks – large plastic sleeves with individual pockets which can hold up to 24 35mm slides, or 15 of 120 transparencies. These can be fitted with bars for suspension in a filing-cabinet drawer and quickly and easily lifted out for viewing. For slide projection, however, it is far safer to use plastic mounts, preferably with glass covers, to avoid the risk of popping and jamming inside the projector.

Rule of Thumb

A good photo library can reach infinitely more potential picture buyers than is possible for an individual and can also make sales to the advertising industry where the biggest reproduction fees are earned.

The different effects that can be created by changing the way a photographic print is mounted and presented are shown here.

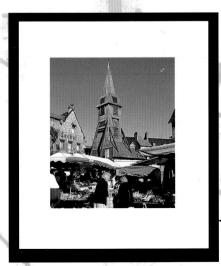

This shot, taken in a French country market, is the type of image regularly in demand by photo libraries and publishers as it can be used to illustrate a wide variety of very general topics such as lifestyle features and holidaying in France, for instance.

Technical Details
35mm SLR Camera with a
35-70mm zoom lens, an 81A
warm-up filter and Fuji Velvia.

Finishing & Presentation

Technique

A slide show can be a very satisfying and enjoyable way of showing your photographs to family and friends with the advantage that they can all view them at the same time. You should edit your **DICTURES** carefully so that there are not too many similar images. It will also be more effective if you plan the sequence of slides in a way which creates variety; follow a photograph containing bright bold colours, for instance, with one which has a more subdued quality, a close-up with a view and a building with a landscape. This will ensure you retain your audience's attention and keep the presentation lively and interesting. A SCripted commentary and even perhaps a Soundtrack could make a slide show of an interesting vacation appreciated by a Wider audience. such as at a camera club or other society.

Rule of Thumb

Look for ways in which you can vary the colour quality and composition of the images so that you are able to juxtapose them in the most effective way. Include both close-ups and long shots, wide-angle pictures with those more tightly framed and images which have different dominant colours. You are, effectively, designing a large image which is composed of many smaller ones, like tiles in a mosaic.

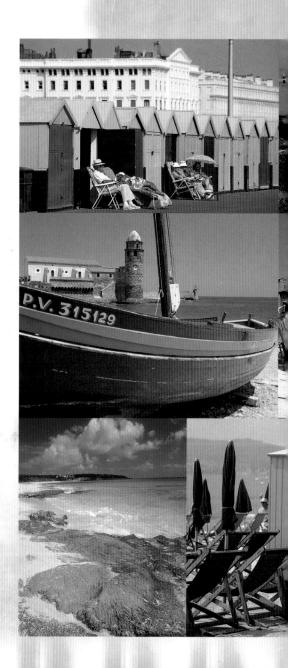

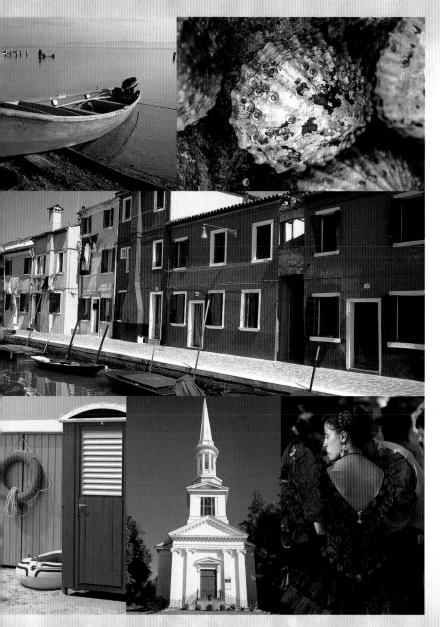

For a more permanent display, a pin board can make an effective and unusual addition to the decor of a kitchen, workroom or office. A large sheet of cork can be hung on a wall and a mosaic of prints fixed to it using either pins or some form of adhesive. Place the prints in a way which creates a pleasing juxtaposition varying both colours and subjects for maximum effect.

Glossary

Aperture Priority

An auto-exposure setting in which the user selects the aperture and the camera's exposure system sets the appropriate shutter speed.

APO Lens

A highly-corrected lens which is designed to give optimum definition at wide apertures and is most often available in the better quality long-focus lenses.

Ariel Perspective

The tendency of distant objects to appear bluer and lighter than close details, thereby enhancing the impression of depth and distance in an image.

Auto-bracketing

A facility available on many cameras which allows three or more exposures to be taken automatically in quick succession giving both more or less than the calculated exposure. Usually adjustable in increments of one third, half or one stop settings and especially useful when shooting colour transparency film.

Bellows Unit

An adjustable device which allows the lens to be extended from the camera body to focus at very close distances.

Black Reflector

A panel with a matt-black surface used to prevent light being reflected back into shadow areas in order to create a dramatic effect.

Cable Release

A flexible device which attaches to the camera's shutter release mechanism and which allows the shutter to be fired without touching the camera.

Close-up Lens

This is a weak positive lens placed in front of a prime lens to enable it to be focused at a closer distance than it is designed for. They can be obtained in various strengths and do not require an increase in exposure, as in the case of extension tubes and bellows units.

Colour Cast

A variation in a colour photograph from the true colour of a subject which is caused by the light source having a different colour temperature to that for which the film is balanced.

Colour Temperature

A means of expressing the specific colour quality of a light source in degrees Kelvin. Daylight colour film is balanced to give accurate colours at around 5,600 degrees Kelvin but daylight can vary from only 3,500 degrees K close to sundown to over 20,000 degrees K in open shade when there is a blue sky.

Cross-processing

The technique of processing colour transparency film in colour negative chemistry, and vice versa, to obtain unusual effects.

Data Back

A camera attachment which allows information like the time and date to be printed on the film alongside, or within the images.

Dedicated Flash

A flash gun which connects to the camera's metering system and controls the power of the flash to produce a correct exposure. Will also work when the flash is bounced or diffused.

Depth of Field

The distance in front and behind the point at which a lens is focused which will be rendered acceptably sharp. It increases when the aperture is made smaller and extends about two thirds behind the point of focus and one third in front. The depth of field becomes smaller when the lens is focused at close distances. A scale indicating depth of field for each aperture is marked on most lens mounts and it can also be judged visually on SLR cameras which have a depth of field preview button.

Double Extension

The term used when the lens is extended beyond the film plane to twice its focal length by the means of Macro focusing, Extension tubes or a Bellows unit to give a life-size image on the film. This requires four times the exposure indicated when the lens is focused at infinity, but will be automatically allowed for when using TTL (through-the-lens) metering.

DX Coding

A system whereby a 35mm camera reads the film speed from a bar code printed on the cassette and sets it automatically.

Evaluative Metering

An exposure-meter setting in which brightness levels are measured from various segments of the image and the results used to compute an average. It's designed to reduce the risk of under- or over-exposing subjects with an abnormal tonal range.

Exposure Compensation

A setting which can be used to give less or more exposure when using the camera's auto-exposure system for subjects which have an abnormal tonal range. Usually adjustable in one third of a stop increments.

Exposure Latitude

The ability of a film to produce an acceptable image when an incorrect exposure is given. Negative films have a significantly greater exposure latitude than transparency films.

Extension Tubes

Tubes of varying lengths which can be fitted between the camera body and lens to allow it to focus at close distances.

Usually available in sets of three different widths.

Fill-in Flash

A camera setting, for use with dedicated flash guns, which controls the light output from a flash unit and allows it to be balanced with the subject's ambient lighting when it is too contrasty or there are deep shadows.

Filter Factor

The amount by which the exposure must be increased to allow for the use of a filter. A x2 filter requires an increase of one stop and a x4 filter requires a two stop exposure increase.

Flash Meter

An exposure meter which is designed to measure the light produced during the very brief burst from a flash unit.

Grey Card

A piece of card which is tinted to reflect 18% of the light falling upon it. It is the standard tone to which exposure meters are calibrated and can be used for substitute exposure readings when the subject is very light or dark in tone.

Honeycomb

A grill-like device which fits over the front of a light reflector to restrict its beam and limit spill.

Hyperfocal Distance

The closest distance at which details will be rendered sharp when the lens is focussed on infinity. By focusing on the Hyperfocal distance you can make maximum use of the depth of field at a given aperture.

Incident Light Reading

A method, involving the use of a hand meter, of measuring the light falling upon a subject instead of that which is reflected from it.

ISO Rating

The standard by which film speeds are measured. Most films fall within the range of ISO 25 to ISO 3200. A film with double the ISO rating needs one stop less exposure and a film with half the ISO rating needs one stop more exposure. The rating is subdivided into one third of a stop settings i.e. 50, 64, 80, or 100.

Macro Lens

A lens which is designed to focus at close distances to produce up to a life-size image of a subject and is corrected to give its best performance at this range.

Matrix Metering

See Evaluative Metering.

Mirror Lock

A device which allows the mirror of an SLR camera to be flipped up before the exposure is made to reduce vibration and avoid loss of sharpness when shooting close-ups or using a long-focus lens.

Polarising Filter

A neutral grey filter which can reduce the brightness of reflections in nonmetallic surfaces such as water, foliage and blue sky.

Programmed Exposure

An auto-exposure setting in which the camera's metering system sets both aperture and shutter speed according to the subject matter and lighting conditions. Usually offering choices like landscape, close-up, portrait, action etc.

Pulling

A means of lowering the stated speed of a film by reducing the development times.

Pushing

A means of increasing the stated speed of a film by increasing the development times.

Reciprocity Failure

The effect when very long exposures are given. Some films become effectively

slower when exposures of more than one second are given and doubling the length of the exposure does not have as much effect as opening up the aperture by one stop.

Reversing Ring

A device which enables an ordinary lens to be mounted back to front on the camera, which allows it to be focused at very close distances and improves the definition.

Shutter Priority

A mode on auto-exposure cameras which allows the photographer to set the shutter speed while the camera's metering system selects the appropriate aperture.

Snoot

A conical device which fits over the front of a light reflector to restrict its beam and limit spill.

Spot Light

A light source fitted with a lens which enables a precisely focused beam of light to be projected.

Spot Metering

A means of measuring the exposure from a small and precise area of the image which is often an option with SLR cameras. It is useful when calculating the exposure from high-contrast subjects or those with an abnormal tonal range.

Substitute Reading

An exposure reading taken from an object of average tone which is illuminated in the same way as the subject. This is a useful way of calculating the exposure for a subject which is much lighter or darker than average.